SUCCESSWITH

LANDSCAPE
PHOTOGRAPHY

TOM TILL

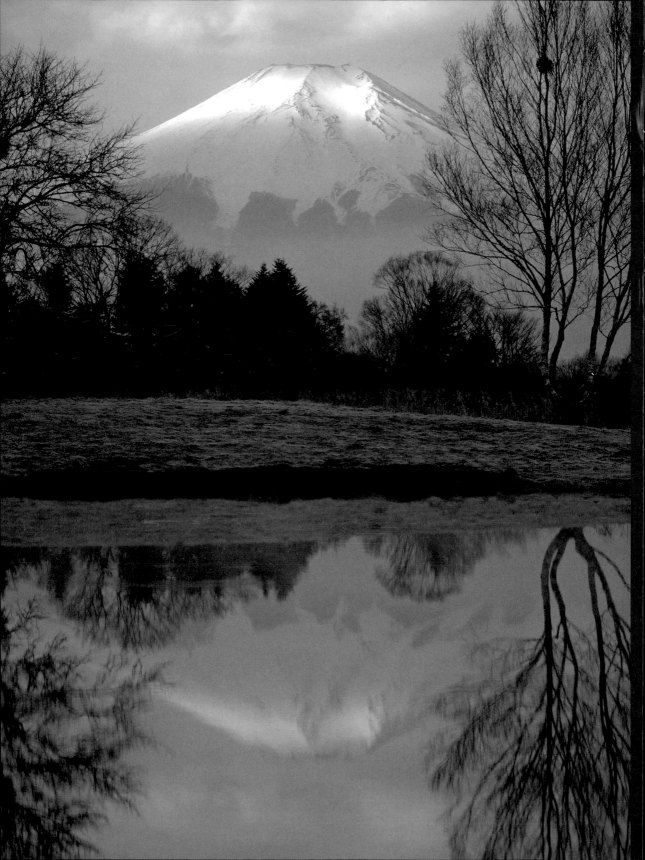

SUCCESS WITH

LANDSCAPE

PHOTOGRAPHY

TOM TILL

photographers'
pip
institute press

First published 2008 by Photographers' Institute Press
an imprint of The Guild of Master Craftsman Publications Ltd
166 High Street, Lewes, East Sussex BN7 1XU

ISBN 978-1-86108-535-1

A catalogue record of this book is available from
the British Library.

Associate Publisher: Jonathan Bailey
Production Manager: Jim Bulley
Managing Editor: Gerrie Purcell
Editor: Tom Mugridge
Managing Art Editor: Gilda Pacitti
Design: Studio Ink

Colour origination: GMC Reprographics
Printed and bound in China by Sino Publishing

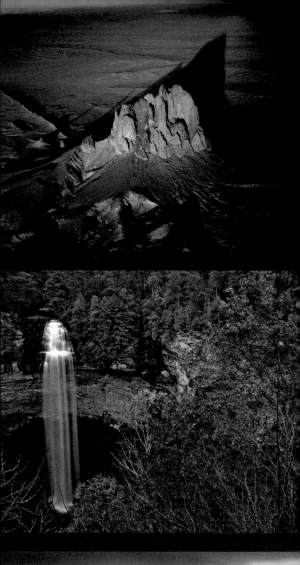

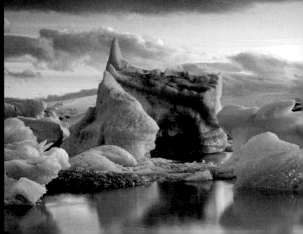

Page 2: Mt. Fuji Reflection, Japan
Toyo Field 45AII camera // Rodenstock 180mm lens //
Kodak VS film // 8 seconds at f45

Top: Aerial view of Shiprock, New Mexico
Pentax 6x7 camera // Rodenstock 90mm lens //
1/1,000 second at f3.5

Middle: Fall Creek Falls, Tennessee
Toyo Field 45AII camera // Rodenstock 120mm lens //
Fuji Velvia 100 film // 1 second at f45

Bottom: Ice floes in Jokulsarlon Lagoon, Iceland
Toyo Field 45AII camera // Rodenstock lens //
Fuji Velvia 50 film // 4 seconds at f45

CONTENTS

INTRODUCTION

Capturing the scene

After four days of heavy rain, the skies showed signs of brightening. I had waited patiently alongside a Norway fjord for any break in the downpour, and now the deluge had diminished to a light mist, while the fog began to dissipate and the sun threatened to peek through the dreary skies. Several days earlier, during the storm, I had scouted a vantage point on the fjord's high cliffs. Sliding dangerously on the muddy slopes I had found a small viewpoint, just big enough for a tripod, to overlook the majestic ocean-filled canyon, while a 400-foot rain-swelled waterfall poured off the cliffs in the foreground.

I quickly drove and hiked to my spectacular perch, and stood amazed at what I saw. Light was playing across the fjord waters creating patterns of light and dark green, and the waterfall smashed its way down nearby with stunning power and grace. To highlight the scene, distant mountains still retained their snow mantle.

For several moments all I could do was stand amazed at what I saw and felt, but I quickly went into work mode, setting up my 4x5 camera and also shooting some images on a digital camera. As I checked my digital images for exposure and composition, I knew I had a wonderful photograph, and all the waiting and dangerous cliff climbing seemed more than worthwhile.

A strategy for better landscape images

Such are the joys of landscape photography, a passion I've pursued with my heart and soul for over 30 years. To say landscape photography has given me a full life is a major understatement. I've won life's lottery – travelling the world, visiting the globe's most beautiful places and striving to capture a little of their beauty on a tiny digital card or a two-dimensional piece of plastic.

In this book, my goal is to guide you towards better landscape photography using what I've learned in the field. The techniques and advice I will give can work well whether you're halfway across the globe or in your own back yard, literally or figuratively. The fun of landscape photography is open to anyone, and if you feel drawn to the beauty of forests, mountains, deserts, seascapes or nature's seasonal displays, I'm certain there will be something in these pages to help you along.

> **PRO TIP**
>
> In the scene opposite, windborne water had covered the branches on the shore of Lake Erie in Ohio, and subsequently frozen solid. The subject was a lucky find, discovered as I strolled along the icy banks of the lake in February. My first decision was to shoot the ice backlit, shooting into the sun from behind the subject. Luck is a big part of landscape photography, but you can increase your chances of a lucky break by spending as much time as possible in the field, especially during 'magic hour', when even mundane subjects like ice take on a magical pink glow.

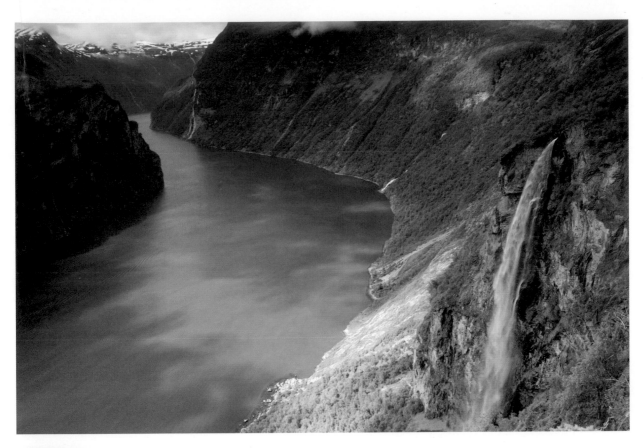

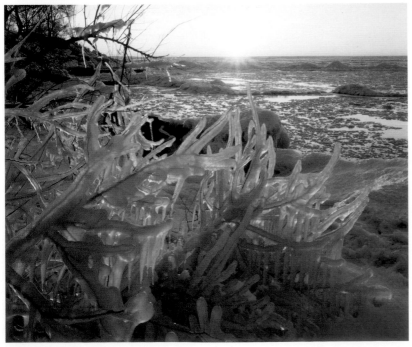

↑ **Geiranger Fjord, Norway**
Fuji Finepix S5 PRO Camera // Nikon
DX 18-200 mm lens at 18mm //
1/3 second at f8

← **Lake Erie, Ohio**
Toyo Field 45All camera // Rodenstock
90mm lens // Fuji Velvia 50 film //
1/3 second at f45

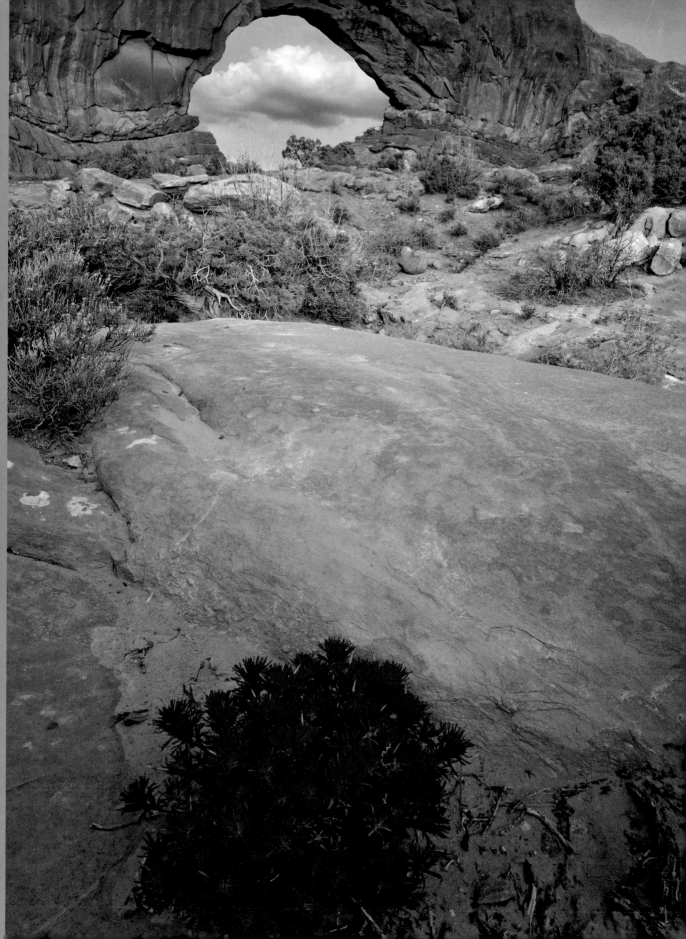

01.

EQUIPMENT FOR THE LANDSCAPE PHOTOGRAPHER

Arches National Park, Utah
Toyo Field 45AII camera // Rodenstock 75mm lens //
Fuji Velvia 50 film

One of the main reasons for lugging around a 50-pound
(23kg) backpack is the ability of the 4x5 camera to easily
maintain focus in a near/far landscape. In this scene, the
flowers were about 8in (20cm) from the camera lens.
I focused on the arch and tilted the back of my camera
until the flowers were in focus, and used a stopped-down
aperture to guarantee depth of field.

CAMERA CHOICES

The digital photography revolution has forever changed the world of landscape photography and offered a staggering array of options for both aspiring and professional photographers. On the one hand, those who love film and its qualities will always be with us – at least as long as manufacturers continue to make the product. On the other hand, the tide of history certainly seems to be flowing in the direction of digital photography. Both media have their advantages.

Perhaps no genre in photography is so geared to large-format photography as landscape imagery. Since the advent of landscape photography on glass plates, most professionals have used 8x10 or 4x5 cameras for their superior detail and the level of control they offer. Now, with 35mm digital cameras approaching the quality of medium-format film models, and digital medium-format cameras sometimes equalling 8x10 in image quality, everything has been turned upside down. Your choice may depend on what you intend to do with your photographs, but these myriad choices have brought forth a whole new world of possibilities.

The camera

Several camera formats vie to be carried in the landscape photographer's camera pack, and your choice should be a careful assessment of what you want to accomplish in photography, how much money you wish to spend, how much weight you want to carry and how large a learning curve you wish to tackle. The chart opposite shows how each format adds up, in both analogue and digital modes. Consider that owning and using more than one format might be the way to go. I, for example, own a system in each category.

THE PERILS OF 4x5

Though shot with a 4x5 camera, this is an example of an image that could have been captured more easily with 35mm. I dodged incoming waves with my tripod; endured stinging, blowing sand; and had to constantly clean the lens and my camera to keep away stray raindrops – not to mention the 17-mile (27km) one-way hike into the site, and the thousands of feet in elevation gain and loss I endured with a 50-pound (23kg) pack on my back. I am probably the only photographer ever to carry a 4x5 to the site, but thinking about it now, I question my sanity.

→ Kalalau Beach, Na Pali Coast State Park, Island of Kauai, Hawaii
Toyo Field 45AII camera // Nikkor 90mm lens // Tiffen Warm Polarizer filter // Fuji Velvia film

All-important accessories

Besides the camera, film and lenses, I consider two other tools indispensable: a good tripod and graduated neutral density filters. Here again, though, vibration-reduction technologies and new Photoshop capabilities may make even these tools redundant.

Post-production

Later in the book we will delve into the world of post-production equipment, from E-6 processing to digital workflow, including equipment for producing mind-blowing, state-of-the-art archival prints with the push of a button. (See Chapter 7, Landscape in the Digital Darkroom.)

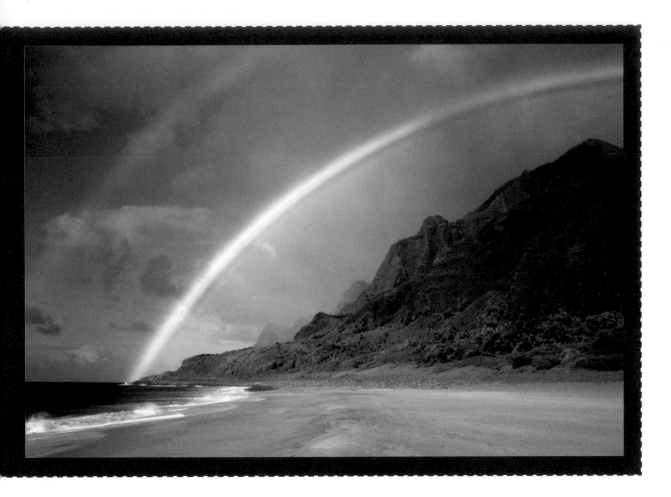

CAMERA FORMATS COMPARED

	COST	WEIGHT	IMAGE QUALITY	EASE OF OPERATION
FILM CAMERAS				
4x5	High	Heavy	Best	Difficult
6x7/645	Medium	Medium	Excellent	Medium
35mm SLR	Low-High	Low	Poor-Excellent	Medium
Compact	Low	Low	Poor	Easy
6x17 Pano	High	Medium	Best	Medium
DIGITAL CAMERAS				
645	High	Medium	Excellent-Best	Medium
DSLR	Medium-High	Medium	Medium-Excellent	Medium
Compact	Low	Low	Poor-Medium	Easy

WHICH FORMAT?

Some people will always be drawn to the craft and the slower pace of 4x5, while others will want the ease of operation and, more and more, the quality of digital 35mm. Anyone expecting to get serious about landscape photography will have to have some knowledge of digital capture and workflow, even if they are shooting film. As time goes by, I see fewer options and availability for analogue film and processing, as many products are retired by their manufacturers.

Using two formats

What do I intend to do? I will always keep a 4x5 and shoot it for as long as film is available, but I also have a digital SLR and I love it. I don't need to carry a 6x17 panoramic camera any more because I can easily stitch my 35mm shots together. I have just purchased a 21-megapixel Canon camera that I will use for longer hikes, telephoto and macro work and overseas travel.

The incredible detail available with a 4x5 camera entices a small number of practitioners to brave the difficulties, weight and expense of diving into the format. I have always loved the fact that in most cases, my published 4x5 shots

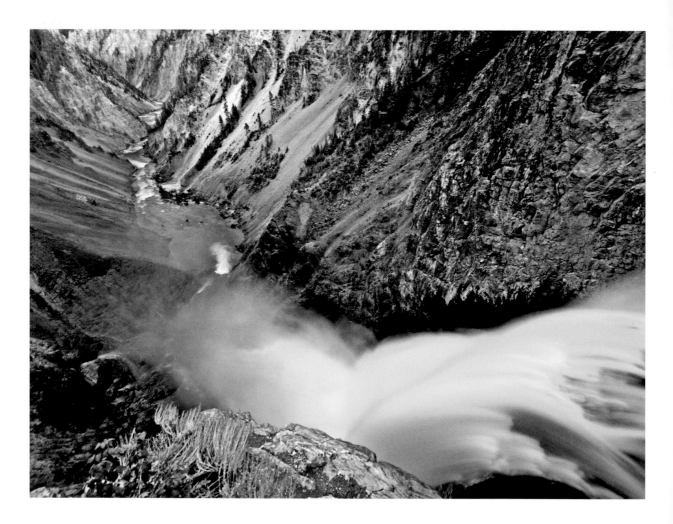

are crisper, sharper and more detailed than my 35mm competitors. Anyone who wishes to make beautiful large prints must also consider the 4x5 as their camera of choice.

Film versus digital

For most people, this will be a simple choice – digital is the wave of the future. But not so fast! Steven Spielberg has said he will always shoot his movies on film, because he loves the medium. There will always be photographers who prefer the 'look' of film, and always those that eschew the advances in technology for the time-honoured, hands-on way of image-making.

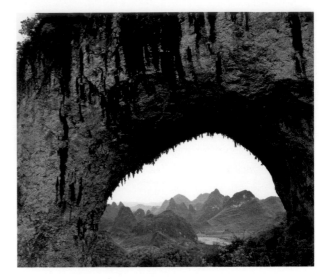

← **Yellowstone National Park, Wyoming**
Toyo Field 45All camera // Schneider 58mm lens // 2 seconds at f32

↗ **Karst formations over the Li River, China**
Toyo Field 45All camera // Rodenstock 210mm lens // Fuji Velvia 50 film // 2 seconds at f45

FILM ADVANTAGES ✔

» Images cannot be lost by camera or computer crashes
» Used analogue equipment can be found at bargain prices
» Analogue equipment is less susceptible to trouble from bad weather
» 4x5 camera provides images that yield one gigabyte of information when scanned
» Joy of looking at your images on the light table

DIGITAL ADVANTAGES ✔

» No film means no processing costs or weight
» No trouble with airport x-ray machines, even in checked luggage
» Immediate feedback on composition and other problems
» No scanning of images required
» Considered by most to be the technology of the future
» Histograms help avoid exposure mistakes
» Ability to use high ISO settings

FILM DISADVANTAGES ✖

» Considered by most to be a dying technology
» High cost of equipment film and processing
» Weight of equipment and film
» Continued removal of some film types from the market
» Film must be scanned to display images on the internet or make digital prints

DIGITAL DISADVANTAGES ✖

» Dirt on digital sensors is much more of a problem than dirt on mirrors or lenses of a film SLR
» 'Cropping' of image because sensor is smaller than 35mm
» Digital viewfinders can give a misleading version of the image you are capturing, sometimes showing exposures and colours that differ from the actual image. Also, at times, the viewfinder may be hard to see
» Dealing with noise and chromatic aberration

COMPACT CAMERAS

If you simply want to dabble in landscape photography without learning a lot of interesting things about shutter speeds, f-stops and the like, maybe a compact camera is the way to go. These cameras are cheap and easy to use – and, used properly, they can deliver good results. I recently saw one with Leica optics and 12-megapixel resolution, which is a great little package.

Compact pros and cons

If, on the other hand, you're serious about landscape photography, you should consider a compact only as spare camera, or if you are visiting a site where a professional-looking camera is forbidden. The bad news about digital compact cameras? First, most feature LCD viewfinders instead of the real deal found on SLRs. Also, compact cameras rarely offer interchangeable lenses, leaving you at the mercy of the one built-in zoom lens. The image sensor on most compacts is smaller and provides lower resolution than a DSLR, although this may be a problem only when you wish to make large prints or try to sell your imagery. Most of the advice in this book is fully applicable to those who choose to use compact cameras or low-megapixel SLRs.

THE SLR WORKHORSE

For most aspiring landscape photographers, whether using digital or film, the single lens reflex camera (SLR) will be the camera of choice. In purchasing a 35mm film camera, check eBay or used camera brokers, as the many photographers who have switched to digital have sold off their old equipment, and many bargain cameras and lenses are to be had. In many cases, you should be able to purchase a much better film system than a digital system for the same price.

If you plan to shoot mostly landscapes, you don't need a lot of bells and whistles on your camera, just a decent entry-level model with good lenses. A high FPS (shooting speed) rate is not important, as you will rarely encounter a situation where you need to shoot many frames per second as a sports or fashion photographer would.

Top quality with a film SLR

If you don't want the expense of jumping into digital, rest assured that you can achieve excellent results with a lower-priced film body, good lenses and good film stock (Fuji Velvia or Kodak VS). Galen Rowell and Art Wolfe, two outstanding landscape photographers, shot with these tools for decades.

PRO TIP

No camera does a better job of capturing a fleeting moment than the 35mm SLR. As fast as I am with a 4x5 camera, I can never match the speed with which a 35mm camera can be composed, focused, metered and shot. Since many of the light events we try to capture are special and very short-lived, the 35mm definitely has the advantage. That rainbow, that moon quickly rising behind the mountain, that desert bathed in pink light – all are more likely to be captured successfully by a 35mm than the other formats. Also, SLRs are best for shooting from aircraft, from boats and without tripods.

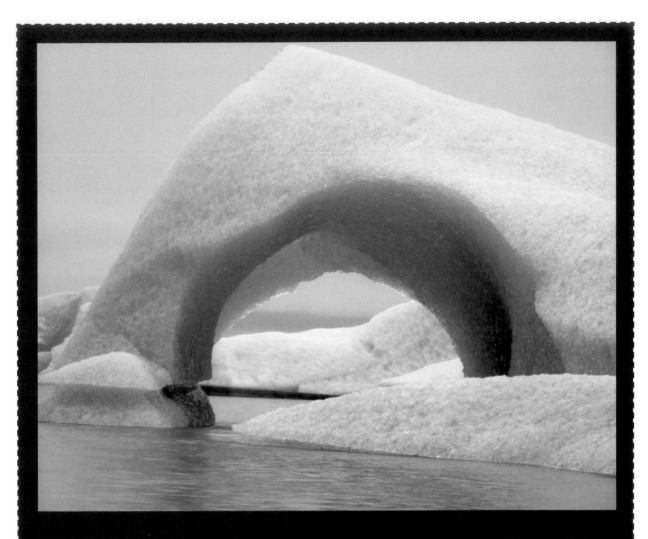

COMPACT CONDITIONS

↑ Glacier Bay National Park and Preserve, Alaska
Fuji FinePix S6000 camera

While shooting from a boat in Alaska, my main 35mm camera failed due to the extremely cold conditions in the ice-filled bay we passed through. My 4x5 was fine, but could only be used on a tripod, so I shot with my wife's compact camera. These were the only images I was able to get in these trying conditions, and they demonstrate a good reason to keep a compact stashed away for just such an emergency.

A WHOLE NEW WORLD: THE DIGITAL SLR

As a confirmed film shooter for my entire career, I was reluctant at first to give 35mm digital cameras a chance – but once I did, I was hooked. Very few professional landscape photographers who shoot 35mm have stayed with film.

Digital SLRs (DSLRs) come in a wide range of models, from those aimed at newcomers to highly advanced cameras for seasoned professionals. Fortunately, landscape photographers may not need all the bells and whistles found on pro models and can get by swimmingly with DSLR bodies in the less expensive range. Also, your choice of a DSLR camera body may depend on the camera system you have already been using, since many of the new bodies will accept lenses you may already own. Generally, lenses like the Nikon DX series will work only on digital bodies, while the Nikon AF lenses can service both digital and analogue models.

Megapixels and image quality

Most landscape photographers are looking for as much detail as possible in their images, and megapixel count is the big factor in attaining this goal. One megapixel equals one million pixels, and is a measure of the capacity for clarity and detail of the camera's digital sensor. Megapixels cost money, and separate the men from the boys in the ranks of available camera bodies. Conventional wisdom says you should buy as many megapixels as you can afford; however, anecdotal information insists that excellent 16x20in (41x51cm) prints can be made from 8-megapixel cameras. Especially with newer cameras, which have been advancing in quality at a torrid pace, 12 megapixels may equal medium-format film cameras in image quality.

MEDIUM–FORMAT ADVENTURE

Medium-format cameras have long been a favourite of landscape photographers itching for a slightly bigger original than 35mm, but who are unwilling to commit to the whole different world a 4x5 camera represents. Many of the controls on a medium-format camera are analogous to those on a 35mm camera, and roll film is used instead of the single sheets of the bigger camera. This film comes in 120 size (10 exposures) or 220 size (20 exposures). The cameras generally come in three sizes, 645 (6x4.5cm), 6x7 (6x7cm) and Hasselblad's 6x6cm square format.

Great results from film

The large transparencies produced by medium-format cameras can reach into the rarefied atmosphere of 4x5 quality. A quick look at used camera brokers' websites reveals lots of medium-format film equipment at bargain prices. Right now, a medium-format film camera might be the best way to get the best-quality image at an affordable price.

Digital medium format

Since cameras like the Canon 21-megapixel model are said to approach or surpass the quality of medium-format film cameras, interest in analogue medium-format cameras has waned considerably, while digital backs for 645 cameras are all the rage, despite their stupendous price tags. These backs – made by Phase One, Hasselblad and others – are compatible with Mamiya and Hasselblad models, although at the time of writing Mamiya was set to bring out a more modestly priced 645 with its own 22-megapixel digital back. This camera will be compatible with all of Mamiya's 645 lenses, including its zoom lenses.

Bigger sensors

Some digital cameras, like the Hasselblad, use sensors that are twice the size of 35mm sensors. This allows the sensor to feature more and larger pixels, producing images that can rival the quality of 4x5 images.

PRO TIP

I carry two camera systems into the field, a 4x5 film camera and a 21-megapixel DSLR. Each has a separate job. The 4x5 work goes to my clients who want to see large-format transparencies, and this work becomes the originals that I scan to make prints of up to 50x60in (127x152cm) for my galleries. Shots from the 35mm camera are immediately downloaded into Adobe Lightroom and prepped for my website and for clients who wish to see digital stock imagery.

↘ Heceta Head Lighthouse, Oregon
Canon EOS-1DS Mark III camera //
EF 17-40mm USM lens at 25mm //
1/160 second at f13 // ISO 400

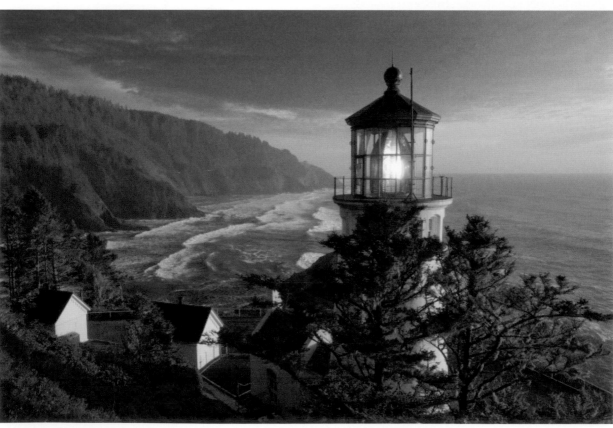

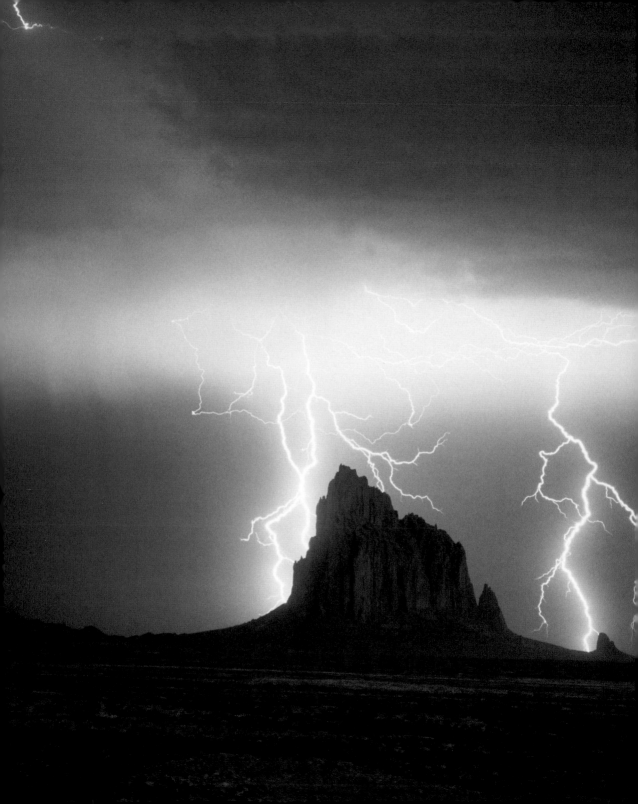

PHOTOGRAPHING LIGHTNING

I use a Pentax 6x7 camera for two main purposes: aerial and lightning photography. My strategy for lightning photography is to use a fast film (400 ISO), and get as close to the lightning as possible. I then leave the shutter open for two to five minutes, with the aperture wide open, and hope for some strikes to occur. It's really a hit-or-miss process, and this particular image took four days of shooting during a series of thunderstorms. The purple colour is common with lightning, adding a nice colour cast, while the fast film allows some detail of the landscape to come through. If lightning gets too close, I take refuge in my camper, leaving the tripod and camera to the mercy of nature. Though I have used the 6x7 camera for greater image detail, in the future I will always use a 35mm digital camera; I can then have instant feedback on capture of the lightning, exposure and composition.

Shiprock, New Mexico
Pentax 6x7 camera // 90mm lens // Fuji 400F film // 5 minutes at f4

PANORAMIC LANDSCAPE PHOTOGRAPHY

Panoramas have always been a vigorous subgenre of landscape photography, particularly in Australia, where the panoramic image is considered the standard for landscapes. The most-used panoramic format is the 6x17cm model, which produces a roll film image with almost as much surface area as a sheet of 4x5in sheet film. For that reason I call the 6x17 a 'poor man's 4x5', since photographers can gain a large surface area image without learning how to use the 4x5. Fuji panoramics can be bought used in two models, an older type with a fixed lens and a later version with interchangeable lenses. Those wishing to purchase a new film 6x17 can look only to Linhof, who still produce cameras and lenses for this format.

A useful format

Since some scenes cry out to be shot as panoramas, and the format is so useful, I often carry both a 4x5 and a panoramic in the field, boosting my pack weight to around 60 pounds (27kg). A much easier way to produce panoramas is to shoot a series of normal- to medium-range images in a series with a DSLR and combine them in Photoshop CS3. A tripod is necessary for this trick, and care must be taken to overlap each image slightly to give the program a reference point from each individual shot. Photoshop has made this process so easy that photographers can see and create a panorama in seconds.

PRO TIP

Some images just work better as a panorama. With a DSLR, and the ease of combining images in Photoshop, it's important to stay open to panoramic possibilities while shooting regular rectangular formats. In the scene shown below, the mountain range, beautiful clouds and aspens all fell into one long thin strip, perfect for a panorama.

↓ Dallas Divide, San Juan Mountains, Colorado
Fuji 6x17 camera // Fuji Velvia 50 220 film // 1 second at f32

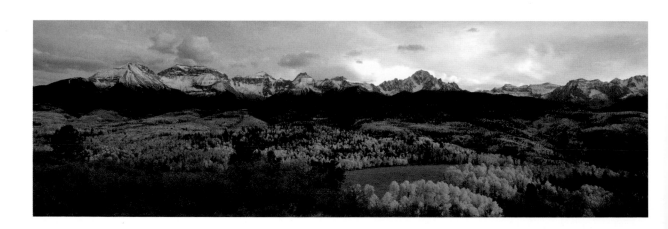

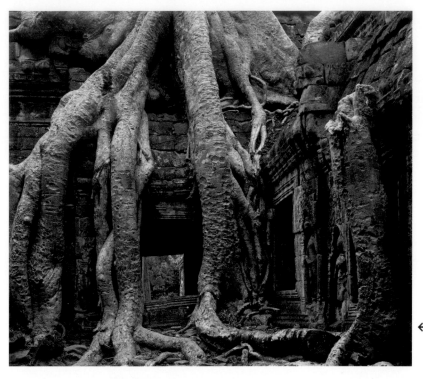

PRO TIP

The 4x5 format's greatness comes to the fore with nature shots that have a great amount of detail. The 4x5 image shown on the left could be enlarged to 50x60in (127x152cm) and still look fabulous.

← **Angkor Wat, Cambodia**
Toyo Field 45AII camera // Schneider
120mm lens // Fuji Velvia 50 film //
1/2 second at f45

4X5: BIG CAMERAS, BIG VISTAS

It's no exaggeration to say that perhaps more published landscape photographs have been made from 4x5 transparencies than any other format. Professionals have used the 4x5 as their camera of choice for many decades, and the camera system still commands a huge following. I love it so much that even though I expect to do most of my work on digital in the coming years, I will never stop shooting 4x5. Why? The amazing control of focus, the beauty of a 4x5 transparency on the light table and the satisfaction of learning a difficult craft are all part of it, but also it's knowing that I'm part of a long tradition that includes nature photography's greatest practitioners.

To go deeply into the how-to of 4x5 cameras is beyond the scope of this book, but those who are considering the format need to understand that 4x5 users often look at their vocation as 'true' photography, and consider 35mm too easy by comparison to count as 'real' photography. Also, this commitment requires time, money, a strong back and the ability to rise above the many frustrations you'll encounter. If you're still game, I can recommend Jack Dykinga's book *Large Format Nature Photography*, which covers the subject better than any other book ever has (see page 172, Further Reading).

The advantages of 4x5

The whole logic of the 4x5 camera for landscapes revolves around the resolution of detail created by the big camera, lens and film. In nature and landscape photography, the goal is to make the viewer experience a little of the location where the image was made; to create a realistic or impressionistic image that will create the illusion of actually being there. The more detail that is offered to the viewer, the more real the connection between reality and the image should be. It's this quest that has kept me dragging a heavy backpack around America and the world for 30 years.

PRO TIP

Although the 4x5 camera comes with a plethora of swings, tilts, rises and other controls, the back tilt is the movement I use by far the most. My basic focusing mantra is: focus on the far, tilt (the back backwards) towards the near, and refocus as necessary. This back tilt also has the effect of increasing the size of the close subject relative to the distant scene. I composed the scene on the right underneath a dark cloth, with the image appearing upside down and backwards. That's just how a 4x5 works.

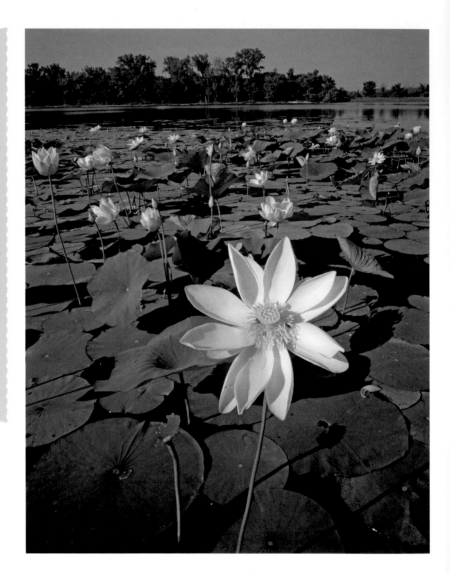

→ **American lotus blooms, De Soto National Wildlife Refuge, Missouri River, Iowa**
Toyo Field 45AII camera // Rodenstock 90mm lens // Fuji Velvia 50 film // 1/4 second at f45

LENSES

Your choice of landscape photography lenses will depend ultimately on the format(s) you intend to use – and, more amorphously, on the way you 'see'. There is a huge range of lens options open to 35mm users, including zoom lenses, while medium format has fewer choices, with 4x5 photographers given the fewest options.

Which lenses?

Different landscape photographers are drawn to different lenses, and for a variety of reasons. David Muench, who has worked mostly with a 4x5 camera, is known for his dramatic wide-angle imagery, while my friend Art Wolfe, who is one of the world's greatest wildlife photographers, uses very long (600mm) lenses for many of his landscapes. Eliot Porter, widely known as the father of colour landscape photography, used mostly normal lenses on his 4x5 camera to capture 'intimate' landscapes, which are carefully composed pieces of the overall big vista. You may eventually find that you are drawn to certain focal lengths over others or that you 'see' wide-angle imagery more often than you 'see' telephoto shots. For hand-held shooting, which I do not recommend, wide-angles work better than longer lenses due to their inherent depth of field, size and magnification factors.

PRO TIP

Lenses for 4x5 cameras each come with an individual shutter, which adds greatly to the weight of the 4x5 kit. One advantage of this feature, however, is that if a shutter malfunctions (as they often do), the front and back lens elements can be removed and put on one of your other lensboards. Though wide angles are widely available for all formats, telephoto lenses for medium and large format are large and expensive – and, with a 4x5, impractical. If you like to use telephotos best for your landscape work, 35mm is the only feasible format.

↘ Driftwood, Lizard Island National Park, Australia
Toyo Field 45AII camera // Rodenstock 75mm lens // Kodak VS film // 1/4 second at f45 // Polarizing filter

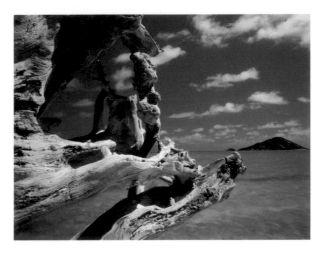

35MM LENSES FOR LANDSCAPES

I've always thought that having as wide a range of lenses as possible was the best strategy, and with the latest advances in 35mm zoom lenses this is possible while carrying only a couple of pieces of glass. I recommend that purchasers of new 35mm lenses also consider the following:

1. Buy zoom lenses whenever possible.
2. Buy ED or equivalent lenses whenever possible (better sharpness and colour).
3. Buy lenses with vibration/stabilization control whenever possible (but only for use where a tripod is not allowed).
4. Buy lenses with the broadest focal-length range as possible to control weight and limit dirt reaching the sensor when lenses are changed.
5. Buy special digital lenses for your DSLR for best results.

Cropping from digital lenses

For 35mm digital you must keep in mind that your lenses will be cropped by the smaller-than-35mm sensor common on most DSLRs. Therefore, your angle of view for a 50mm lens will be cropped from the 'normal' to about 75mm; a 20mm becomes a 28mm; and a 200mm becomes a 300mm angle of view. Since this is a crop and not a real focal-length change, the depth of field (wider-angle lenses have more inherent depth-of-field capabilities) remains the same as the original focal length. A little complicated, but if you choose 50mm on your zoom you will have the depth of field of a 50mm lens, but the angle of view of a 75mm. All this works to the advantage of those who like to use long focal-length lenses. A 400mm, for example, now becomes a 600mm. For wide shooters, however, this means real

trouble and a new way of thinking. What before was a fisheye lens, is now just a wide angle. For example, a Tamron zoom lens of 11-18mm now covers the angle of view of 17-28mm on a 35mm camera. Since landscape photography relies heavily on wide-angle shooting, serious landscape photographers entering the digital realm will almost certainly want to have one of these lenses. The good news is that paired with the Nikkor 18-200mm, photographers can have the focal length of 17-300mm covered in two lightweight lenses.

FISHEYE OPPORTUNITY

Mesa Arch is shot here with a fisheye 25mm lens on a 6x7 camera. Notice how the arch slightly curls around the sides in a pleasing departure from the usual view. This scene is a perfect place to use the fisheye, since the area in which the arch can be shot is very small. Unfortunately, however, the mountains and buttes seen through the arch also become very small.

→ **Canyonlands National Park, Utah**
Pentax 6x7 camera // 25mm lens // Kodak VS 220 film

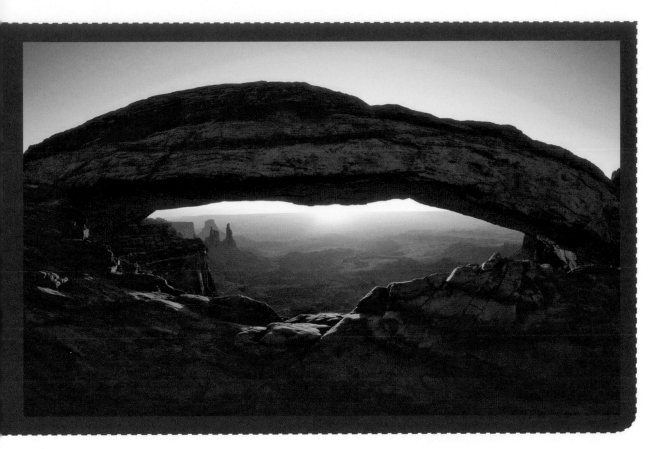

WIDE–ANGLE LENSES

The most popular category of lenses for landscape photography is the wide-angle range. This group would include 10-35mm on 35mm, 35mm-55mm on 6x7 and 38mm-150mm on 4x5. Wide-angle lenses allow for great near/far compositions with an interesting foreground and a distant vista, magnificent cloudscapes combined with landscapes, and the ability to shoot in 'tight' places – caves, canyons and small vantage points. Also, keep in mind that many cutting-edge images or 'new' takes on over-photographed landscapes can come from lenses at the two extremes – both wide-angle and telephoto.

Paradoxically, wide-angle lenses are somewhat difficult to use. If you go very wide, you risk your shining mountains shrinking to distant hills. Also, if you are planning a near/far composition, your near subject must be selected with great care. A beautiful mountain range with a scruffy wilted flower in the foreground is not going to cut it. I can spend hours searching for a foreground after I've found an acceptable backdrop.

Very wide-angle or fisheye lenses now come in versions with very little distortion. Sometimes I like to use the distortion to produce interesting graphic shapes, while at other times I use the less distorted lens to make the scene look more 'normal'. For beginners, I suggest practising with the more moderate wide-angle lenses, and becoming comfortable with them, before moving on to the super-wides.

↘

'NORMAL' LENSES

The lenses in this category are in the region of 50mm for 35mm, 90mm for 6x7 and 210mm for 4x5. They are deemed 'normal' because they are supposed to simulate the eye's normal angle of view. The normal lens is also the type you will usually get 'free' if you buy a camera/lens package. I use normal lenses mostly for shooting out of aeroplane windows, and for intimate landscapes and medium close-ups. Most professionals, if asked to pick only two (non-zoom) lenses to take on a shoot, would not choose a normal lens.

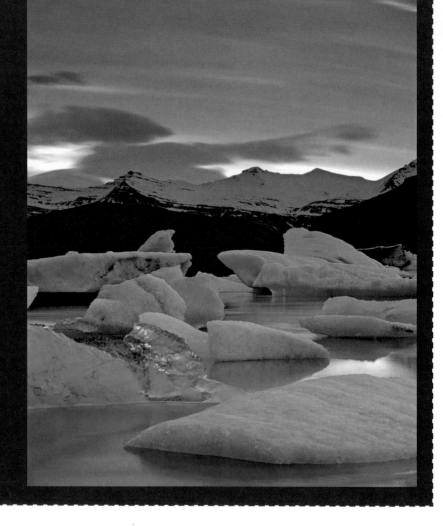

MIDNIGHT SUN

Exciting images can sometimes be made with a 'normal' lens. Since 4x5 photographers are often stuck with a limited number of focal lengths, making 'normal' work is always a challenge. This image is part of my 'James Bond' series – landscape photographs taken at places featured in Bond films. Because of the lingering midnight sun, the sunset lasted for over an hour, allowing me plenty of time to get into position. Although I did a number of shots with medium telephotos and wide angles, I like this one best.

→ **Jokulsarlon Lagoon Preserve, Iceland**
Toyo Field 45AII camera // Rodenstock 210mm lens // Fuji Velvia 50 film // 4 seconds at f45 // 4-stop GND filter

TELEPHOTO LAYERS

When you're shooting with a telephoto lens, the compression of distance can sometimes stack up layers of landscape, which can create pleasing repeated patterns that give the viewer the idea of distance and dimension.

← **Mountain ridges and Persian ruin, Sultanate of Oman**
Nikon D200 camera // Nikkor 80-200 lens // Fuji Velvia 50 film // 1/60 second at f8

TELEPHOTO LENSES

Telephoto lenses range from 70–1,000 on 35mm, 35-500 on 6x7 and 240–600 on 4x5 cameras. The cropping by digital sensors in DSLR cameras makes a short angle of view quite common, so many lens buyers will find they have a lot of telephoto bang for the buck from their new digital lenses.

High-quality glass
I recommend all longer lenses be ED glass or equivalent. These coatings cost more, but are well worth the price in colour fidelity, sharpness and reduction of flare, which Canon claims is more prevalent with DSLRs than SLRs. The coatings were originally used mostly on telephoto lenses, but are now used on most high-quality glass.

Telephoto lenses are known for their ability to compress distance, and in so doing they sometimes have a tendency to make images look one-dimensional. One way around this is to use layers of colour, shape, or light and dark to simulate three dimensions.

Telephotos with larger formats
Photographers wishing to use telephoto lenses with medium- and large-format cameras will find their options limited. Even moderate telephotos for these formats tend to be large and expensive. My 300mm for my Pentax 6x7 weighs about six pounds (2.7kg)! To use my 600mm on my 4x5 (the equivalent of about 180mm on 35mm) I must use a very sturdy Linhof camera and rack the bellows out to over 400mm. Working with telephotos on high-megapixel 35mm cameras seems the best choice.

ZOOM LENSES

The ease of use and the quality of state-of-the-art zoom lenses for 35mm, and for some 645 cameras, makes them the most appealing choice for landscape photography use. The ability to pick your focal length to exactly fit your composition is a major advantage. With single focal-length lenses, photographers must do the opposite – fit the scene to their lens, an often frustrating and unproductive task, especially when light conditions are changing fast.

Lightweight zooms

If you pursue landscape photography in any serious way, you are going to be walking at some point, and you may be walking a great deal. By choosing a good DSLR and three zoom lenses, you can cover every focal length from 14mm to 600mm. By cutting down to just two lenses, giving you 14mm to 300mm, you will be carrying very little extra weight with your primary equipment.

As technology has progressed, camera manufacturers have widened the focal lengths available in zooms to include wide-angle, normal and telephoto focal lengths in one lens. This is an amazing revolution, allowing the landscape photographer to consider carrying just one high-quality lens into the field.

Another advantage of the all-in-one lens is dirt reduction on the image sensor. If the lens is never or rarely changed, dirt can't get in, dramatically reducing this serious and nagging DSLR problem.

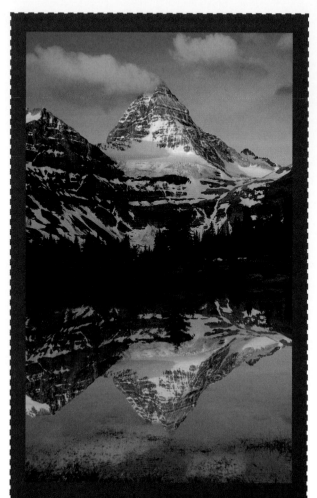

ZOOMING TO CROP

Using a zoom lens on this photo allowed me to achieve the exact crop I wanted (31mm), something that is not possible with single focal-length lenses.

↑ Mt. Assiniboine Provinicial Park, British Columbia, Canada
Fuji FinePix Pro camera // 100 ISO film // 1/2 second at f25 // 3-stop GND

REDUCING CAMERA SHAKE

On page 37 of this book you'll find a forceful lecture from me about always, always using a tripod, but for various reasons, using a tripod is not always possible. Shooting 4x5 without a tripod is almost impossible anyway, but I've had some success using a gyrostabilizer (a small tube with whirling gyros inside) to substitute for a tripod on 6x7 format, both on the ground and in aeroplanes. In 35mm, things are easier. Several manufacturers offer stabilizers in their lenses and bodies that can offer up to four stops of steadiness over what you could expect in handheld situations. If you hate tripods, or like to shoot in places where tripods might be banned (more places than you would think), purchasing these vibration-reduction or image-stabilization lenses and bodies is a very good choice. With older lenses it's important to turn off the feature when using a tripod, but with some newer lenses the feature can be left operating at all times.

↓ **Keukenhof Gardens, Netherlands**
Toyo Field 45AII camera // Nikkor 360mm lens // 2 seconds at f45

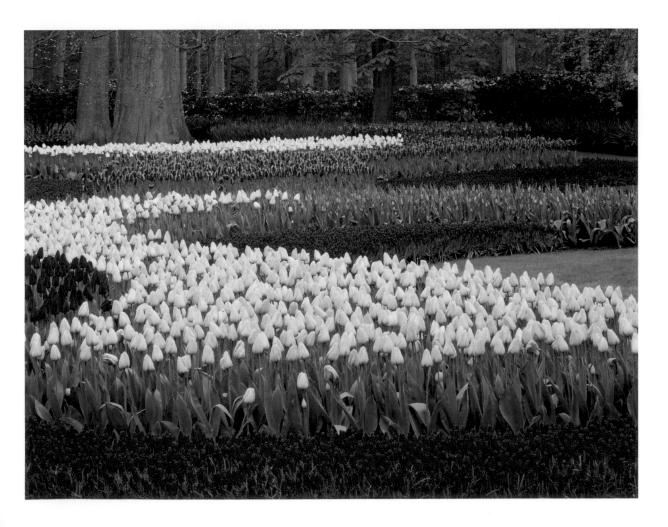

↘

CLEANING EQUIPMENT

The outdoors is a dirty place. Out there you will encounter dirt, sand, dust, mud and all sorts of natural and unnatural pollutants. Keeping equipment clean ensures better images and adds to the life of your expensive equipment.

For 4x5 and 6x7 bodies (not mirrors) at home I use a small air compressor and wand to clean off dust, along with a small wet towel. In the field I use anti-static brushes and I'm quite high on the Giottos Rocket Blaster, which delivers a powerful stream of air in a small package. For all lenses and my LCD screen I use micro-fibre brushes. Once again, don't use these products on your SLR mirror.

DSLRs and dirt

Cleaning a DSLR sensor is a different matter entirely. I have had very little dirt on my sensors, so far, but I like the Delkin Sensor Scope System. With a magnifier to view your sensor, and both wet and dry cleaning options, it seems to be the most capable system out there. Some cameras, like the Canon 21-megapixel model, use a whole suite of strategies: vibrating the sensor, catching dirt on an adhesive surface, and providing software to digitally bust dust. The technology is advancing continually for other DSLR models, too.

Dirt can also be a nasty problem for film users. With the 4x5 camera I use individually loaded sheets of 4x5 film sealed in paper, called Readyloads or Quickloads. They cost much more than individual sheets of film, but they can save money in scanning and digital retouching. For roll film holders, it's important to keep your film chamber very clean – especially the pressure plate, which is notorious for digging attached grains of sand into your film's emulsion and scratching whole rolls at a time.

↘

USING FILTERS

> **THE TRUTH ABOUT FILTERS**
>
> 1. Most professionals use filtration.
> 2. Most professionals use filtration a great deal.
> 3. Filtration is important even for DSLR users.
> 4. Using more than one filter at a time can produce excellent results.
> 5. Using filters effectively is an important part of landscape photography.
> 6. Filtration should not call undue attention to itself.
> 7. Making major changes in color with filtration doesn't work well.
> 8. Graduated neutral density filters (GNDs) are one of the most important tools for any landscape photographer.
> 9. Many colour-added GND filters are ugly.

Every aspiring landscape photographer needs to spend time experimenting with and perfecting their filter usage. One American 4x5 photographer who has had a stellar career once told me 'Everything is filtered'. I also borrowed a lens from another very successful photographer only to notice that a polarizer was permanently stuck on the front element. Selling polarized images had been so successful for him that he used it on 100 percent of his images.

→ **Ammonoosuc River, White Mountain National Forest, New Hampshire**
Toyo Field 45AII camera // 360mm lens // Fuji Velvia 50 film // 4 seconds at f45

Two filters were used on this autumn scene – a common practice for me. I used a Tiffen Warm Polarizer to saturate the autumn colour, and a three-stop GND to block down the non-shaded part of the image. Also, this shot was completely pre-visualized, meaning that I knew the white rocks in open shade would go very blue, reflecting the blue sky above.

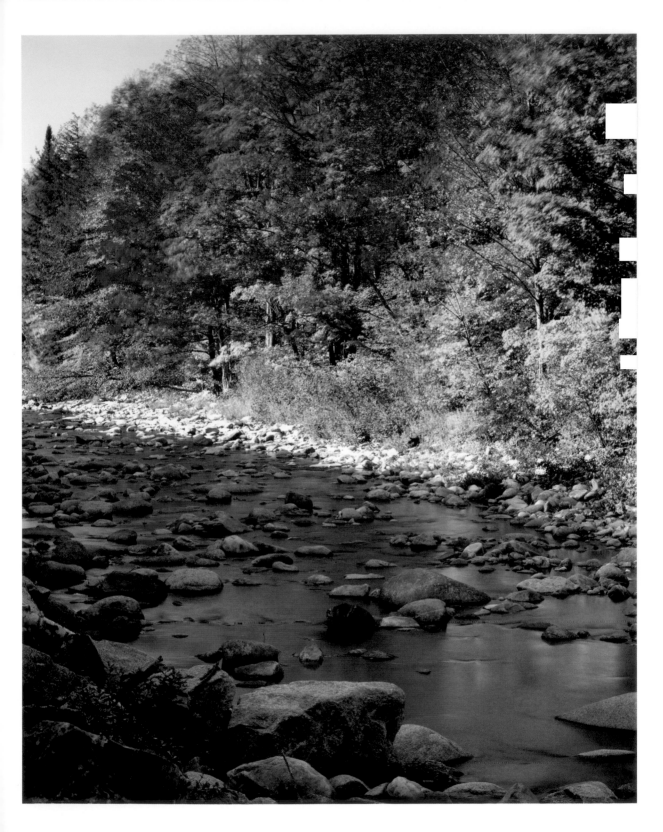

BRIGHT SUNRISE

A GND filter with three stops of gradation (darkness) was placed diagonally (by turning the Lee System from normal to the left) to cover the bright sunrise light. A check with my light meter indicated that the icy trees and the blocked-down sun were only one stop apart in exposure, easily within the film's dynamic range.

↑ **Mississippi River, Iowa**
Toyo Field 45All camera // Schneider 120mm lens // Fuji Velvia 50 film // 1 second at f45

Filter choices

Filters come in two basic styles: screw-in, which screw directly into the back or front of the lens or on top of another lens; and filter holders, which also screw onto the lens and then hold square or rectangular filters in place in front of the lens. I use both styles, but vastly prefer the filter-holder style for graduated neutral density (GND) filters. As we will see on the next page, it's important to position GNDs in the correct position to block bright areas of the scene, and a rectangular filter in a holder works best this way.

My choice of filter holder is the Lee System, which I find to be the best made, easiest to use and most versatile holder system available. The Lee System comes with screw-in ring adaptors that easily fit on the front of your lens. I prefer

the special recessed wide-angle adaptor that ensures no vignetting with wide-angle lenses. Filter holders are then snapped onto the rings and can be turned a full 360 degrees. They can hold multiple filters, including polarizers, warming filters or any other choice.

It's important to note that many effects that were formerly achieved with filters can now be approximated by Lightroom and other software. Most photographers find that a switch to digital will mean using filters less often.

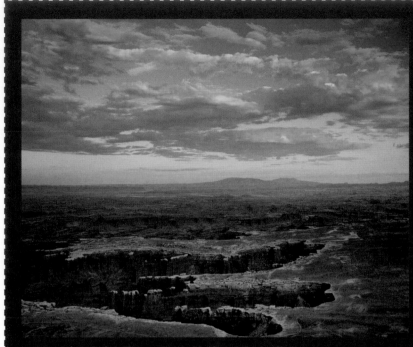

NATURAL CLOUDS

I use GNDs very frequently, even with my digital camera. After the composition is set, my next decision is usually whether a GND is needed. In this shot, my light meter reading told me that the difference in light value between the brightest part of the cloud and the darkest canyon walls was about five stops: definitely GND territory. I used my strongest grad – a full three stops – to block the sky and bring down the contrast to just two stops. Since the filter is colourless, the beautiful clouds look totally natural.

↑ Grandview Point, Canyonlands National Park, Utah
Toyo Field 45All camera // Fuji Velvia 50 film // 4 seconds at f32

GRADUATED NEUTRAL DENSITY FILTERS

I have already alluded to the importance that GND filters have in my work (see page 10). These invaluable pieces of equipment have a single purpose: to control the contrast inherent in colour-transparency and digital-capture media. By 'contrast', I mean the difference between the light and dark areas of the scene you intend to photograph. Neither digital nor film capture has the capability to render in the final image the full range of light values that the human eye can see. One of a photographer's biggest challenges, especially outdoors in natural light, is to see as the film or the sensor in a digital camera 'sees'.

In an average scene, part of the picture might be in shadow, while another part may be sunlit and bright. Exposing correctly for the shadow area will 'burn out' the bright segment; conversely, exposing for the bright area will leave the shadowed area too dark. Graduated neutral density filters use a dark area to cover the bright areas and a clear area for the dark areas to even out the contrast and create a smooth range of density throughout the entire photograph.

Using GNDs

Graduated neutral density filters come in several configurations, and the nomenclature is somewhat confusing. I generally use Singh Ray GNDs: rectangular plastic filters that can be moved up and down and turned 360 degrees in the Lee filter holders. The dark area of the filter gradually (hence the 'graduated' designation) decreases density to the clear area about halfway down the filter. I prefer the four-stop filter for most situations with contrasty transparency film, and I prefer the soft grads, where the dark area gradually moves to light, to the hard grads that have a more solid line of gradation. Most digital camera users will probably find a three-stop grad more acceptable for less contrasty digital output.

COLOUR FILTERS

I use warming filters more often than cooling filters, but both items could be the first things to leave out of your backpack if you're shooting digital, because the excellent colour-correction facilities in Adobe Photoshop or Lightroom can take care of what these filters would normally do. If you're shooting film, I find the Tiffen 812 filter to be a good all-purpose subtle warming filter. I can also recommend the LEE 81B and CC10 RED filter for the same purpose. Cool-coloured filters can come in handy, but if I really want to accentuate blues in an image, I usually find that a blue polarizer works better.

GND SECRETS

1. GNDs work just as well with 4x5 and medium-format cameras as with 35mm.

2. GNDs work well with polarizing and other colour filters.

3. Avoid GNDs that add a 'tobacco' or other coloration to the graduated filter section.

4. GNDs can work turned upside down, sideways, and, if you get a large filter, for tiny portions of the scene.

5. Keep GNDs in their cases and treat them with care – they're expensive and easily scratched.

6. It's difficult to use a GND in the rain, unless there's no wind and you've got an umbrella. Water tends to get on both sides of the filter, so keeping it dry is a very frustrating process.

7. On many GNDs the darkest area is one stop less dark than the designation. For example, a four-stop grad really may only block three stops. Check your filter with your light meter to see if you need to compensate for this common discrepancy.

8. GNDs can be handheld if time is short or you don't want to fumble with the holder. Be careful to get the GND as close as possible to the lens, as reflections from the filter can show up in the image if the filter is too far away. While handholding the GND, you can also move it slowly up and down to create a dodging and burning effect.

9. It's almost always difficult to see the effect of the GND through the lens. I move the GND up and down in the holder several times, which allows me to see the blocked area and get the filter in the right spot.

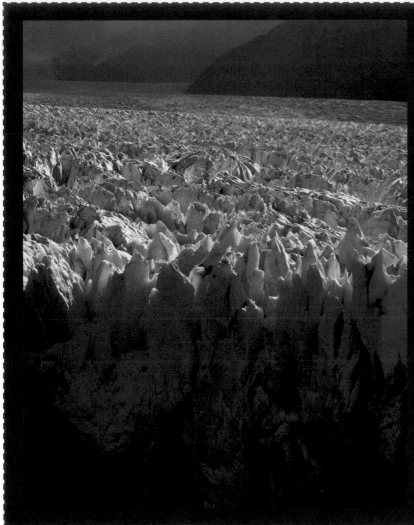

SHADES OF BLUE

For film shooters, one primary use for warming filters is to push down the blues that may appear under overcast or open shade conditions. Although most new films, such as Velvia, perform very well in rendering warm colours in cloudy situations, the subtle addition of a bit more warming can give warm colours and greens a little more pop. Conversely, one skill to develop is to try to attune your eye to the blue in nature and learn to exploit it. I believe most people pay little attention to blue colours unless they are overwhelming. Film and digital cameras pick up this colour when our eyes don't, but with some practise you can become more aware of the beautiful shades of blue that are more common than you may think.

← Moreno Glacier, Los Glaciares National Park, Argentina
Toyo Field 45All camera // 360mm lens // 1 second at f45

↘ Mt. Cook National Park, New Zealand
Fuji FinePix S5Pro DSLR camera // 40mm lens // f8 // Polarizing filter

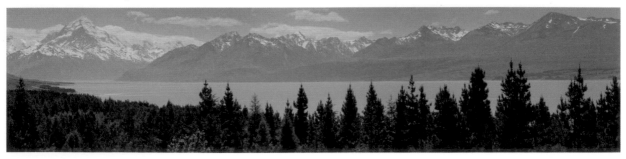

POLARIZING FILTERS

I am a strong advocate of the use of polarizing filters with both film and digital cameras. Recent advances in technology have ensured that most new polarizers produce a very pleasing effect, without the almost black skies that sometimes occurred with older models. My usual choice is the Tiffen Warm Polarizer, which combines the polarizing effect with an 812 filter, a very weak red filter. Adobe Lightroom, an image-processing program we'll discuss in detail in Chapter 7, can sometimes fairly accurately simulate the effect of a polarizing filter in the digital darkroom.

↘ Intalula Island, Bacuit Bay, Philippines
Toyo Field 45All camera // Schneider 110mm lens // Kodak VS film //
1 second at f45

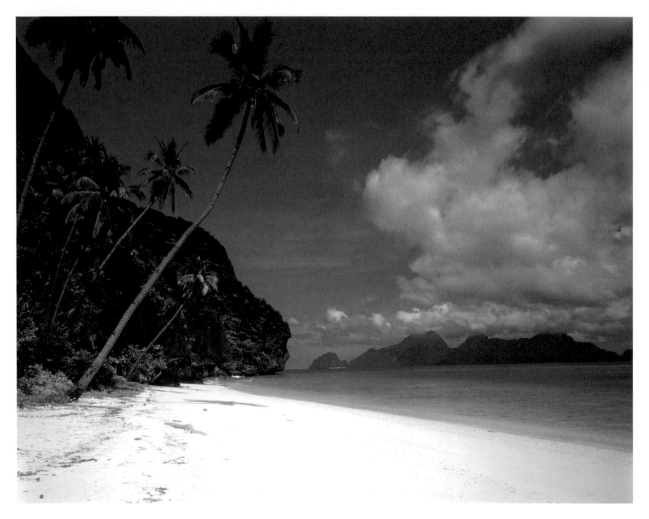

THE BENEFITS OF POLARIZING FILTERS

» Sky colours are deeper blue and clouds are strongly separated from the sky.

» Shiny, colourful subjects (leaves, water, flowers, rocks, wet subjects) have degrading light removed, leaving pure colour.

» Colours in rainbows can be strengthened or erased.

» Polarizers work well during midday hours.

» Polarizers can work well in conjunction with GND filters.

THE IMPORTANCE OF TRIPODS

Speaking strictly from an equipment standpoint, the accessory that will improve your landscape photography the most is a good tripod. I've been amazed over the years as I've taught workshops to find that many people just don't take this admonition seriously. If I could leave you with one equipment tip from this book that I consider most important, it is to acquire and use a good tripod. Yes, they're a little heavy, and yes, it's a hassle to set one up and use it, but this is the small price you pay for better images. Also, be prepared to spend some money on a top brand. I've always used Manfrotto or Gitzo tripods and can vouch for their quality.

Tripod tricks

Make sure your tripod has a quick-release plate. These attach to the bottom of your camera and slide or lock on to the tripod head. These are essential to ensure quick setup of your camera and tripod.

Getting your tripod down to ground level and as high as possible will allow you to put your camera in unusual positions that can make for interesting images. I make sure my tripod will go flat on the ground by sawing off part of the centre column, and making sure my tripod legs will machine-gun out and lock from the centre. At the same time, I like to get tripods with as many leg segments as I can to make sure I can get the tripod as elevated as possible.

Carbon-fibre tripods are the best for outdoor use, combining strength with light weight. New generations of these models are even tougher and lighter than earlier models.

Tripod heads

New-generation tripod ball heads combine toughness and versatility in a small, lightweight package. Though I have been a pan/tilt tripod-head user for decades, I have switched to ball heads in recent years, and have grown used to their idiosyncrasies. My favourite brand is the Really Right Stuff Head with its L-bracket that allows you to move quickly between vertical or horizontal positions with your SLR.

PRO TIP

Polarizers work well in all directions when the sun is high in the sky, but have no effect when the sun is low and you are shooting with the sun behind or in front of you. They're especially useful for beach shots, coaxing the maximum blue out of both sky and water.

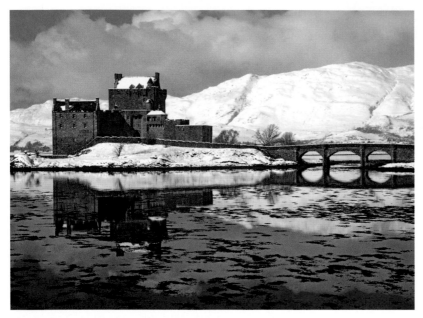

↗ **Eilean Donan Castle in winter, Scotland**
Toyo Field 45AII camera // Rodenstock 210mm lens // Kodak VS film // 1/2 second at f45

PRO TIP

When shooting snow scenes in cold climates – such as western Scotland, shown left – I try to spend most of the day outdoors, even if I have a warm car to escape to. To keep warm, I wear a fleece jacket, hat, trousers, fingerless gloves and underwear along with high-topped Gore-Tex hiking boots. In this case, I had my Gore-Tex windbreaker nearby, but I didn't need it until sunset.

FILM AND MEMORY CARDS

Analogue cameras are named by the size of film they require: 4x5in, 220mm and 35mm. 4x5 film either comes in boxes to be loaded into film holders by hand, or in factory-loaded holders that hold one sheet. The sheets then go into a special holder for exposure. Though the Readyload or Quickload (as the latter type are called) varieties are more expensive than box film, I prefer them because they are impervious to dirt and scratches that can ruin your original transparencies. If your film is scanned later, the cleaner sheets of film mean less cleaning time.

What kind of film?

Transparency film is the standard for analogue landscape photography, and Fuji Velvia and Kodak VS are the choices of most professionals. Though I prefer Velvia 100 and Kodak for their speed – their sensitivity to light allows for shorter exposures – enough professional nature shooters loved the old Velvia 50 to convince Fuji to bring it back. In general, I find Kodak film to be less contrasty, so it's easier to hit the correct exposure. Those moving from colour negative to transparency film (my strong recommendation) will find it much harder to expose correctly on transparency film.

Memory cards

The size of the memory cards you purchase should be based on the size of the files you'll be creating with your digital camera. Shooting with a 21-megapixel Canon camera on the RAW setting, I need the largest capacity cards available – though some people believe that filling the cards up completely can make them more likely to malfunction. I also download my images onto a laptop computer (an Apple Air) as a backup. Keep your cards clean; if you're careful, they can be safely erased and reused hundreds of times – although they can malfunction at any time.

BACKPACKS & WEATHER GEAR

A 4x5 camera with a set of lenses, light meter, dark cloth and film can weigh over 40 pounds (18kg). To handle such a heavy load, I've always used a Lowepro Super Trekker Backpack. With Lowepro's long experience with backpacks that shoulder heavy loads, I find this pack has the best belt and suspension system of any camera backpack.

For my 35mm kit, I use a smaller Lowepro backpack, the Primus AW, which holds two DSLRs and four to six lenses. Once again, the Primus is made for all-weather use and offers unsurpassed comfort and protection for the equipment. I also use the waterproof Lowepro backpack on river trips and when swimming with my equipment.

Preparing for the outdoors

Though it's not exactly camera equipment, as an outdoor photographer you're only as good as the clothing that enables you to brave the elements for long periods of time. In winter, you'll need gear that allows you to comfortably spend many hours outdoors and won't bathe you in sweat as you walk or ski to and from your desired location.

Your winter outdoor gear should also be able to protect you from sudden changes in the weather. These qualities are also important at times for changeable spring and autumn weather. In summer, protection from the sun and insects is an important concern. Having the right outdoor clothing can make the difference between life and death. Also, since I prefer to work in stormy conditions, protection from rain, snow, and wind is an important consideration. I've been a long-time fan of Patagonia outdoor clothing. Made specifically for climbers and other active outdoor enthusiasts, Patagonia's clothing is always state of the art, versatile, comfortable and lightweight.

Footwear is also an important consideration, as cold wet feet don't translate to the kind of contemplative mind one needs to photograph the great outdoors. I use high-topped Gore-Tex boots, and conversely Teva sandals when shooting along the ocean in tropical climes. Patagonia has just introduced boots into their product line. I've found them to be the best boots I've ever had, and Patagonia is well known for its support of wilderness and the integrity of great landscapes.

Keeping a weather eye

Serious landscape photographers need to become diligent weather watchers – both to plan for what clothing to take on a trip, and to hunt down interesting conditions in the field. These conditions can range from lack of wind, which produces wonderful reflections, to winter snow that can make a mundane subject magical – and everything in between. I keep constant track of upcoming weather on my computer and television for exactly this purpose. At times, I might travel hundreds of miles or wait several days to get the kind of weather conditions I want, and I use forecasts as a guide.

CAMERA CRAFT

Landscape photography may be an art, but it is also a craft. Like movie-making, it is a combination of technology and artistry, so the landscape photographer must be part geek and part artist. Craft and artistry become so intertwined in photography that it's sometimes difficult to talk about one without the other. It does the landscape photographer no good to focus correctly if the composition is poor or the light is not right, and a fantastic composition with beautiful lighting can be ruined by being out of focus.

The format a photographer chooses determines, at least partially, the level of craft involved. Learning to shoot with a 4x5 camera requires much more practice and skill than shooting with a digital SLR. Also, the number of mistakes that a photographer can make with a 4x5 is greater than with a digital SLR. With today's technology and a digital SLR, just about any problem or error in camera craft — exposure, focus or camera blur — can be solved by the camera itself, or in Adobe Lightroom software (see Chapter 7).

As with any pursuit, you'll get out what you put in, and there's no substitute in camera craft for a meticulous frame of mind.

↗ **Antelope Canyon, Arizona**
Toyo Field 45All camera // Rodenstock 75mm lens // Fuji Velvia film // 6 seconds at f45

PRO TIP

The old maxim of 'shoot, shoot, shoot' applies particularly to landscape photography. Practice and experience are the greatest teachers. Many of the best opportunities that will come your way in the field will require you to work rapidly, almost without thinking. The more you shoot and perfect your camera craft, the better prepared you'll be for the great short-lived moments that nature is fond of delivering. In a slot canyon (the deep narrow canyons of the American Southwest), the light changes every few seconds. Light rays appear and disappear without warning. As quickly as a scene is composed, it changes, requiring a split-second response from the photographer. To prepare for such situations, shoot, shoot, shoot until all the aspects of camera craft become second nature.

EXPOSURE AND CAMERA CONTROLS

All exposures are a combination of two elements: shutter speed and aperture settings. Learning how these simple controls work is critical to getting good exposures and controlling motion (whether moving objects will create blur) and depth of field (the amount of your scene that appears in sharp focus). In workshops I've taught, I've been amazed at how these simple controls puzzle aspiring photographers, and how many stagger on in the dark, unable to master these simple concepts. Learning how aperture works, at a bare minimum, is critical to creating good landscape photographs.

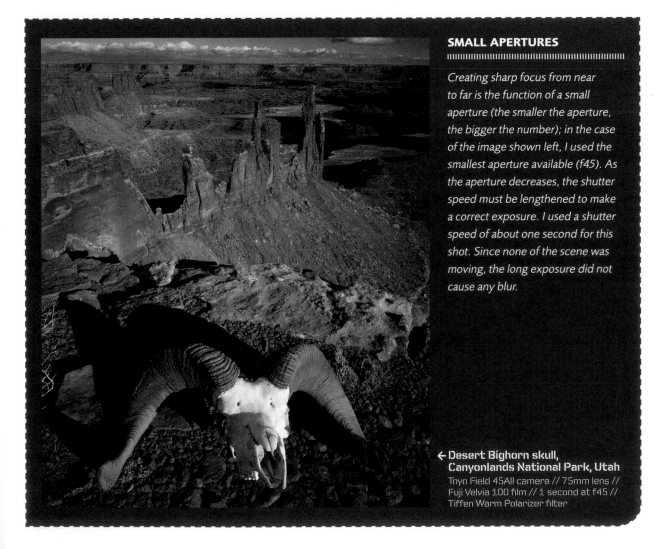

SMALL APERTURES

Creating sharp focus from near to far is the function of a small aperture (the smaller the aperture, the bigger the number); in the case of the image shown left, I used the smallest aperture available (f45). As the aperture decreases, the shutter speed must be lengthened to make a correct exposure. I used a shutter speed of about one second for this shot. Since none of the scene was moving, the long exposure did not cause any blur.

← **Desert Bighorn skull, Canyonlands National Park, Utah**
Toyo Field 45AII camera // 75mm lens // Fuji Velvia 100 film // 1 second at f45 // Tiffen Warm Polarizer filter

CAPTURING A GOOD EXPOSURE

Your strategy for capturing the correct exposure will depend on which format you choose. There are no built-in meters on 4x5 cameras, so a handheld meter is necessary. I use a combination of techniques to get a correct exposure on expensive sheet film. These same techniques can be used in medium format or with a 35mm camera to get good exposures.

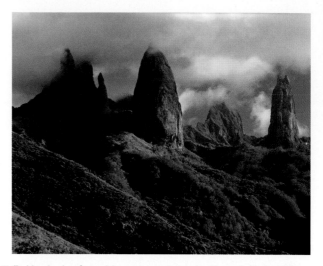

↗ **Cathedral spires, Marquesas Islands, French Polynesia**
Toyo Field A45II camera // Nikkor 360mm lens // Kodak VS film //
1 second at f32

EXPOSURE TECHNIQUES

1. Use a spot light meter that gives light readings from small parts of the scene you intend to shoot, rather than an overall average.

2. Understand that light meters are looking for an average colour (17 percent grey) to base their reading upon, and to produce a correct exposure. Most subjects are other colours than 17 percent grey.

3. I use my hand (lit with the same light I need to meter) as a grey card and subtract $1\frac{1}{2}$ stops of exposure from that reading.

4. I compare this reading expressed in the digital light meter as a number called an exposure value or EV (14 would be an average sunny day number, while 10 might express a subject lit by overcast light). Let's say my reading is 14. This exposure value is then set on a dial that offers every combination of aperture and shutter speed that will create a correct exposure with the EV 14.

5. Keeping the EV in mind, I now begin to measure parts of the actual scene with the spot meter to compare them to my baseline grey EV number. Brightly lit clouds may give me a number of 16, while a shadowed area in the same scene might be 12. Since 14 is the average of these two numbers, and my grey card (my hand) EV is 14, I know that 14 is a good starting place for my best guess at an overall exposure.

6. If necessary, I may want to consider a two- or three-stop GND if the lowest number in this scenario was dropping down to 11 or 10.

7. Though this may sound complicated, remember that for the most part, landscape photographers shoot the same kinds of light over and over. My light meter EV rarely moves outside the range of 15–10. After a little practice, you'll find that you're shooting the same exposures over and over, and you may only need to use a meter in unusual circumstances.

8. If an amazing, short-lived scene is appearing before my 4x5 camera, I often forego metering and trust my instincts about exposure. I would rather guess and capture the moment than waste time metering and miss the shot.

9. Always bracket your exposures, using the auto bracket feature on your camera.

10. Continually check your histogram exposures for gross problems such as extremely overexposed or underexposed shots. These problems seem to turn up inexplicably with DSLRs, so stay alert for them.

METERING WITH A DSLR

Obtaining a correct exposure with an SLR or especially a DSLR is a much less tricky business than working with a light meter. Most SLRs have very sophisticated metering systems that hardly ever allow a mistake. There are sometimes many different approaches on a single camera, but I prefer the metering systems that acquire data from as many divergent parts of the image as possible. In most instances I will trust this reading and then bracket exposures, checking my screen for major problems.

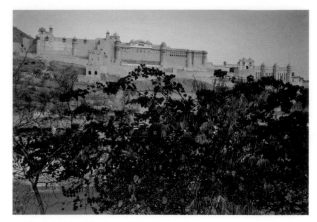

↗ **Amber Fort, India**
Canon EOS 1DS Mark III camera // 24-105
USM lens at 40mm // 2.5 seconds at f22 //
4-stop GND filter

Highlights (too bright) and shadows (too deep)

Even with a great SLR metering system, you may be trying to photograph a scene that has light values that are too contrasty. As discussed on pages 33–34, a GND can be a godsend in such situations, blocking down bright areas to match the exposure values of the shadows in your scene. Sometimes, though, there may be patches of light over the entire scene, which make using a GND impractical. A new feature of Photoshop CS3 called HDR, or High Dynamic Range, can combine exposures with differing values and pull out and merge together the correctly exposed portions of each into a new image.

Bracketing

You'll find that there are very few professional landscape photographers who do not bracket their exposures. Basically, bracketing means taking the meter-indicated exposure as a starting point and shooting one lighter and one darker exposure, usually in the $\frac{2}{3}$- to 1-stop range. With colour transparency film, this should always be done, but I do it with my digital camera also, using the automatic bracketing settings that are included on most modern SLRs.

Assessing a correct exposure

When you receive the transparencies back, or when you are looking at your digital capture on screen, how do you tell which images are correctly exposed? The rendition of whites or other bright highlight colours is the key element, because there should always be detail or colour in the white areas. If these areas are correctly exposed, you must live with the rest of the exposure unless you have used GND filters, HDR in Photoshop or Fill Light in Lightroom.

HISTOGRAMS ON YOUR DSLR

A histogram is a graphic representation of your exposure displayed on your DSLR's LCD screen, and it can be a helpful aid in alerting you to exposure problems. My original feeling about histograms was that I didn't want to spend lots of precious time in the field staring at a little graph; I'd rather quickly bracket exposures. But I was wrong. I've become a true convert to histogram use and if you take a little time to look at them and start using them, I think you will be, too. They are amazing tools for obtaining correct exposures both in the field and in the digital darkroom.

About histograms

A histogram shows the exposure values, contrast and colour in an image. When you're shooting in the field, the key thing to look for on your camera histogram is the bulk of the graph being bunched up against the left side of the graph, which indicates underexposure and possible 'clipping' (no shadow information). The opposite is true for overexposure, with the graph stacked up against the right side. This is even worse – in many images, clipping or overexposing the highlights may be an unfixable problem.

Histograms can also help you in your editing process. Two bracketed images may look almost the same to your eye, but you would be better off selecting one in which the highlights are not clipped. I remember this term from my rock and roll days. A guitar signal sent to an amplifier would 'clip' or overload the amplifier, causing distortion. That is something that guitar players usually want, but audiophiles and photographers do not. With this basic knowledge in mind, start looking at the histograms on your camera, and it will all start to make sense.

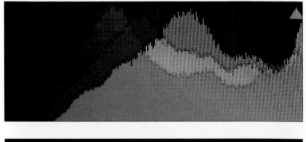

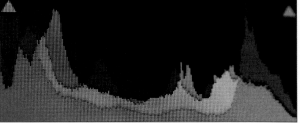

In the top histogram, the graph is bunched up on the right side (the large grey hump), and achieving a correct exposure image will be difficult. The histogram below shows a more correctly exposed image, with only a small part of the grey exposure value touching the right side. The Exposure slider in Lightroom could be used to pull the grey off the side completely.

PRO TIP

Histograms really work well in conditions when the image is hard to see in the viewfinder. By looking at the histogram I can tell if my exposure is working well. This would be especially useful in slot canyons (see Pro Tip, page 42), and for cityscapes at twilight or at night. Some photographers champion the idea of shooting exposures with the histogram bunched up on the right side, reasoning that shadow detail is more likely to be preserved with this technique. I have found this mostly to be true. I try to push the histogram to the right as much as possible without touching the right side. Sometimes, with small, very bright areas, this may not be completely possible. My histogram has become my sole source of exposure information and my brackets, if needed, are based on the histogram. I will add or subtract light to the image (through shutter speed in aperture priority) to fine-tune my histogram.

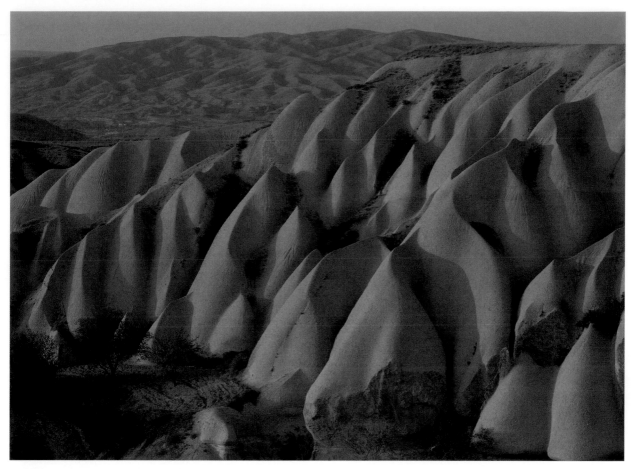

↑ Tufaceous Rock Formations, Goreme National Park, Turkey
Toyo Field 45All camera // Nikkor 360mm lens // Fuji Velvia 50 film // 1 second at f45

↘

SHOOTING RAW

I always shoot in RAW mode with my DSLR cameras. Although the resulting files are comparatively large, RAW capture will produce the best-quality image your camera is capable of – and unlike the JPEG alternative, a RAW image is uncompressed, meaning that no data is lost. Since image quality is a cornerstone of landscape photography, starting out with the highest-quality original will ensure that your raw material is the best you can possibly obtain.

Underexposure for effect

A common practice in the days of Kodachrome was to underexpose the transparency film, especially if the image was destined for publication. Printers and separators liked the richer colours of the underexposure to use in printing. Some professionals have advocated the same trick for digital exposures. The idea is to create the slightly underexposed file to maximize colour saturation and ensure correctly exposed highlights, and to add the shadow detail in the digital darkroom. Lightroom has a number of strategies for pulling this detail back into the underexposed image (see Chapter 7).

APERTURE

If you are not familiar with this part of the photography equation, please pay particular attention now, because aperture and depth of field are the most critical camera settings for landscape photography.

Aperture settings, called f-stops, refer to the size of the iris in the camera's lens. The iris controls two things: the amount of light admitted to the film or sensor; and depth of field – the amount of the final image that appears in sharp focus. On most SLR cameras, the 'A' setting will allow you to control the aperture setting.

Wide-open apertures

This term refers to the f-setting in which the iris is completely open and maximum light is allowed to flow through. The f-stop for this setting is usually a low number (a low number means a high amount of light and low depth of field). This number – say, f2.8 – also denotes the 'speed' of the lens. Faster lenses with lower numbers usually cost more than slower lenses, but fast lenses are not necessary for most landscape photography (except in 4x5 format, where fast lenses are required to see the image under a dark cloth).

Wide-open apertures present the least amount of in-focus area available with the lens, and are sometimes used for selective focus, where the background is heavily blurred – as in macro and portrait photography. With any SLR, it is very important to know that you will be seeing a wide-open aperture view of your scene through the viewfinder. This allows you to compose and see your scene with as much light as possible.

Wide-open apertures provide the maximum amount of light available through the lens to the film or sensor, but aperture settings are just one half of the exposure equation: each exposure is a combination of the aperture setting and the shutter speed (see page 54 for more information on shutter speed).

Stopped-down aperture

Stopping down the aperture will increase depth of field in your image. As the f-stop numbers become larger, the depth of field increases, reaching its maximum for each lens at its highest number – this may range from f22 to f64, depending on format and lens.

With 4x5, very high f-stops are needed to obtain acceptable depth of field. Almost all my 4x5 shooting is done at f22-f64. I also err on the side of caution and use a stopped-down setting with most of my 35mm shots. Remember, although you may stop your 35mm lens down to f32, what you see through the viewfinder is the wide-open aperture setting with its inherent lack of depth of field. When the shutter snaps the image, your camera uses the stopped-down aperture you have set, gives you the depth of field you want and returns to a wide-open setting for the next shot. The depth-of-field preview button, if your camera has one, gives you a dark (remember the iris is smaller and allows less light to pass) and usually indecipherable version of the depth of field in your image. You must accept by faith that if you stop down the camera and use the larger-number f-settings you will get the depth of field you need.

Since the aperture has been darkened to provide depth of field, the camera must now choose a longer shutter speed (on the 'A' setting of your camera this should work automatically) to create a correct exposure. Of course, this longer shutter speed will probably be longer than the time you can safely handhold your camera for a sharp image. The solution is a tripod, which I use with every image I make.

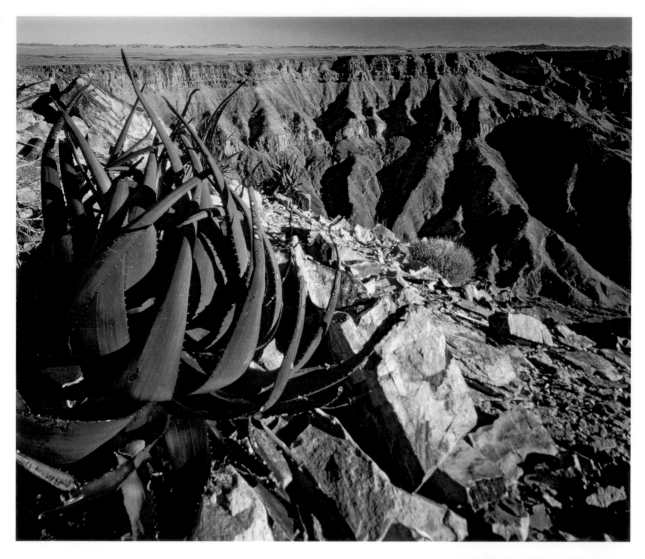

↗ **Fish River Canyon National Park, Namibia**
Toyo Field 45AII camera // Schneider 90mm lens //
Fuji 50F film // 1/2 second at f45

PRO TIP

A close foreground subject and distant scenery can make the viewer feel they can walk right into the frame, the goal of many landscape images. The more interesting, colourful and unusual the foreground subject, the better the template works.

DEPTH OF FIELD

Although aperture setting is the main depth-of-field control, other factors have a major effect on this critical technique. With a 4x5 or tilt-and-shift lens (available for some 35mm cameras), camera movements, particularly front or back tilt or swing, can have a major effect on increasing depth of field.

Focal length and depth of field

Due to the physics of optical instruments, longer focal-length lenses have less depth-of-field capability than wider angles. A 14mm lens, for example, fully stopped down, can portray everything from several inches to infinity (anything far enough away to appear sharp in your photo) as sharply focused, while a 500mm lens may only be able to obtain a range of 60ft (18m) to infinity under the same circumstances.

PRO TIP

When judging where to focus, the 'one-third of the way in' rule works well, especially if you fudge your focus towards your nearest subject (or if it's very close, just behind it), and make sure to stop all the way down for near/far depth of focus. Checking your focus on your DSLR and bracketing your focal point may also be useful. In the Great Wall of China scene on the opposite page, I focused just past the doorway and stopped my lens all the way down.

Focusing and depth of field

Where you focus (remember, you can only focus on one point) also has an effect on the depth of field or focus in your final image. Finding the best place to focus for maximum depth of focus for any lens is critical to control depth of field. Many casual camera users always focus on infinity and wonder why they never obtain depth of focus in their images. The critical focus location is called the 'hyperfocal distance'. If you think of your focus point as a large pane of glass, any focus point would have depth of focus extending in front of and beyond it. As you stop down, this in-focus area increases both in front of and behind the pane of glass. Focusing on the hyperfocal distance allows maximum use of this focused area in both directions.

Hyperfocal distance

Most older-model, single focal-length lenses had a hyperfocal distance scale marked on the camera. You may have wondered what all those cryptic markings (f-stops, feet, metres, infinity) were for. That nomenclature made focusing for maximum depth of focus child's play. All a photographer needed to do was focus the lens to place the highest aperture number next to the infinity mark and shoot away – depth-of-focus problem solved in seconds.

Determining the hyperfocal distance

Since 35mm zoom lenses usually do not have a hyperfocal distance scale, photographers are left with the task of estimating hyperfocal distance themselves. Charts are available that can guide you, but carrying them around in the field and fussing with them seems to be ineffective for me. In general, the hyperfocal distance rule states that twice as much depth of field extends beyond the point of focus as in front. This explains why focusing on infinity is a losing proposition for maximizing

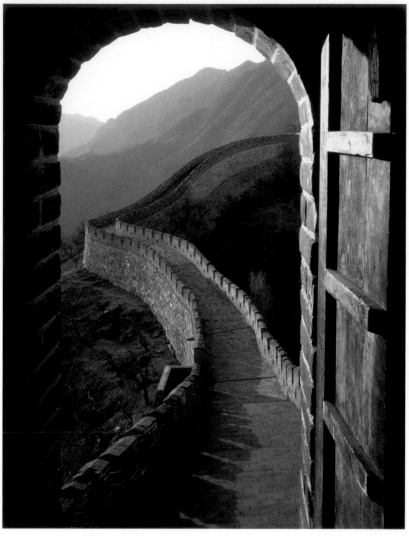

← The Great Wall, China
Toyo Field 45AII camera // Nikkor 90mm lens
// Fuji Velvia 50 film // 1 second at f45

depth of focus. Using the depth-of-field preview button on your camera can be a big help to see where to focus for maximum depth of field. On film cameras I find this method rather ineffective due to the dimness of the image, but many DSLRs provide a bright view even when the camera is stopped down, which is a big help. Using your preview button, with your lens stopped down, check to see if your entire scene is in focus. If not, try moving the point of focus closer or nearer to find the hyperfocal distance. Chances are you will be moving the focus closer to you to achieve this goal.

When to use infinity

With most lenses, if your subject is more than 100 yards (91m) away, focusing on infinity is fine. It will not be necessary to stop your camera all the way down, but I suggest using f8 to cover your bases.

Autofocus strategy

For infinity shots, or scenes requiring little depth of field, I often use the autofocus feature of my Canon. When depth of field is crucial, I focus manually using the techniques described earlier. Bracketing for depth of field is also a good idea.

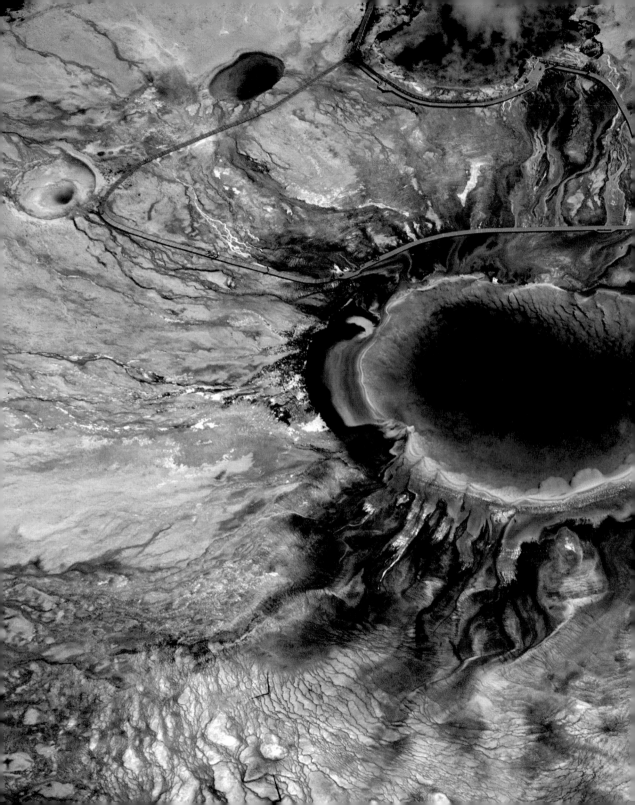

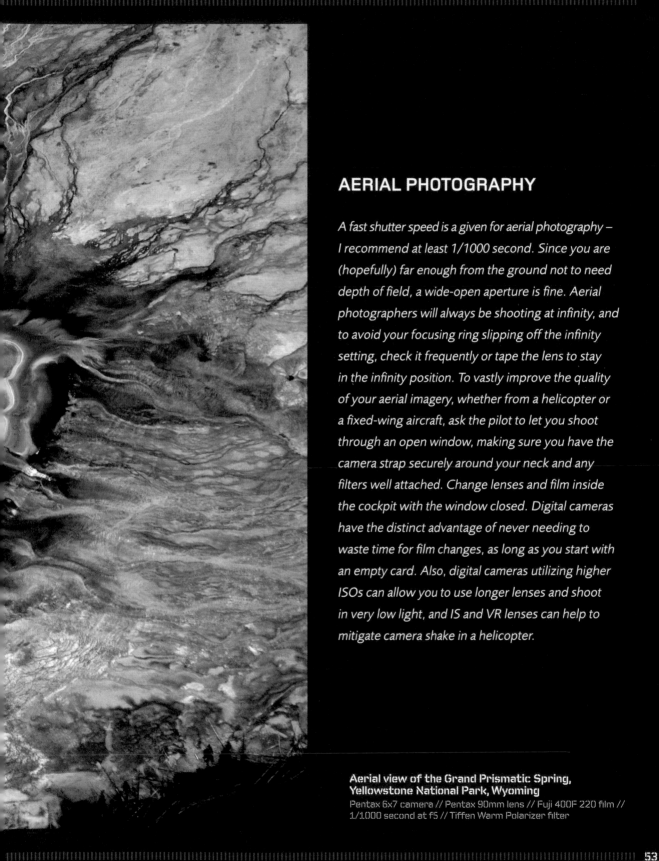

AERIAL PHOTOGRAPHY

*A fast shutter speed is a given for aerial photography –
I recommend at least 1/1000 second. Since you are
(hopefully) far enough from the ground not to need
depth of field, a wide-open aperture is fine. Aerial
photographers will always be shooting at infinity, and
to avoid your focusing ring slipping off the infinity
setting, check it frequently or tape the lens to stay
in the infinity position. To vastly improve the quality
of your aerial imagery, whether from a helicopter or
a fixed-wing aircraft, ask the pilot to let you shoot
through an open window, making sure you have the
camera strap securely around your neck and any
filters well attached. Change lenses and film inside
the cockpit with the window closed. Digital cameras
have the distinct advantage of never needing to
waste time for film changes, as long as you start with
an empty card. Also, digital cameras utilizing higher
ISOs can allow you to use longer lenses and shoot
in very low light, and IS and VR lenses can help to
mitigate camera shake in a helicopter.*

**Aerial view of the Grand Prismatic Spring,
Yellowstone National Park, Wyoming**
Pentax 6x7 camera // Pentax 90mm lens // Fuji 400F 220 film //
1/1000 second at f5 // Tiffen Warm Polarizer filter

SHUTTER SPEED AND MOTION

Like the aperture setting, the shutter speed has dominion over two important functions: exposure and motion. Most of the time, landscape photographers are trying to avoid the blur of motion for sharp landscape images, so the control is used mostly to stop motion rather than create it. Stopping motion is easily done by choosing a fast shutter speed on your camera controls; this is usually designated as 'S'. Since every exposure is made up of two elements, aperture and shutter speed, a fast shutter speed will require a wide-open aperture to create a correct exposure. This creates a problem, since aperture is so important to landscape imagery.

Alternatives to fast shutter speeds

Wind causes most of the problems with motion in landscape photography, and on very windy days, I suggest passing on landscape photography altogether. With 4x5 cameras, windy conditions turn the camera bellows into a sail, creating huge problems for sharp photographs. Medium-format and 35mm cameras fare better, as long as the wind is not so strong that it will send your precious equipment crashing to the ground.

On days when wind is a minor nuisance, I may try shooting scenes that require small depth of field, like distant mountains with no foreground, or I may spend hours waiting for a clump of foreground wild flowers to stay still for a second.

Most of the time, shutter speed can be happily forgotten. Remember that usually, of the two controls that combine to make an exposure, aperture is much more important in landscape photography than shutter speed, and you will most often select an aperture and let the shutter speed be what it will be.

ISO

ISO is the number given to designate the sensitivity to light of a film or a DSLR's sensor. Most professionals try to use the finest-grain film possible for maximum fidelity, and in most cases this film has a low ISO number of 50 or 100. Recent advances in film technology have produced film that has a fairly tight grain at 400 ISO, and an amazing lack of grain at 100 ISO. The Fuji 100 Provia and Velvia films are prime examples.

Most SLRs set the ISO number automatically when the film is loaded. With handheld light meters, the number must be set by the photographer. I try to stay with with one ISO number for my 4x5 by using Velvia 100 and Kodak 100 VS film. This eliminates the possibility of having my meter set to the wrong number, although the dials on handheld meters can move on their own and should be checked before each shooting session.

ISO with the DSLR

DSLR users can set the camera for any ISO they choose, but as with film, lower settings are recommended for outdoor work. I use 100 for my DSLR to match the film settings of my film cameras, and to reduce the 'noise' that can creep into images at faster settings. ISO settings change the exposure value or EV, so working in one ISO provides predictability of exposure in similar lighting situations.

Newer DSLRs can offer much higher ISO settings than film cameras. When you're shooting without a tripod or in wind, this can be a godsend, but beware of noise and chromatic aberration.

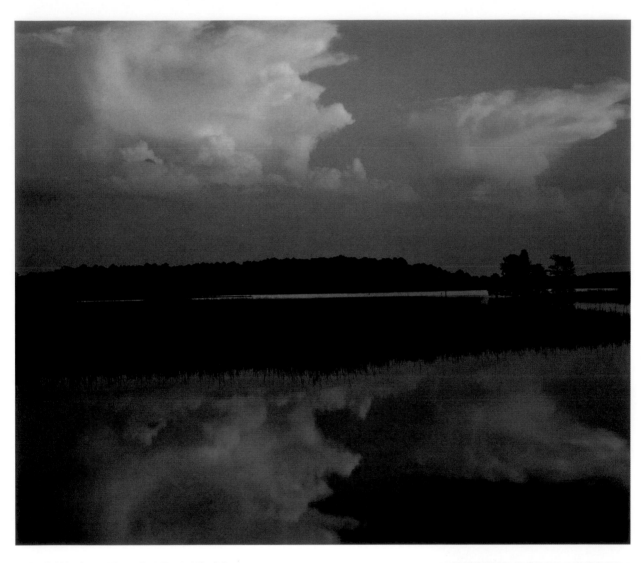

↗ **Colonial National Historical Park, Virginia**
Toyo Field 45All camera // Rodenstock 90mm lens //
Fuji Velvia 100 film // 4 seconds at f45 // 2-stop
GND filter

PRO TIP

*Fuji 100 film shows lack of grain
and gives you an extra stop –
very useful when shooting in
low-light conditions like the
Virginia sunset shown above.*

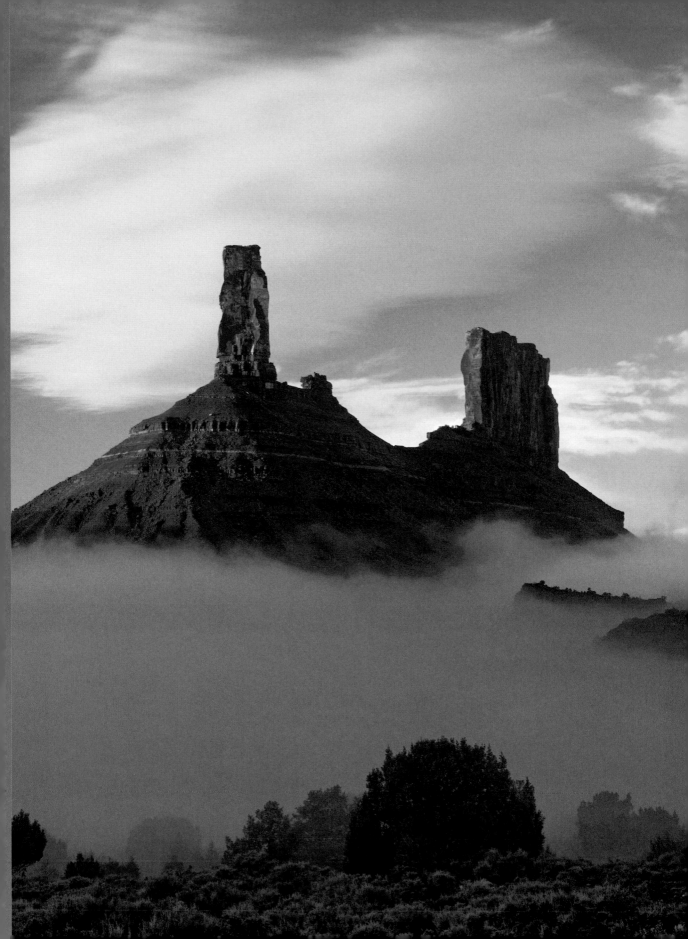

03

LIGHT: THE MAIN INGREDIENT

Castle Rock in Fog, Castle Valley, Utah
Toyo Field 45AII camera // Nikkor 360mm lens // Fuji Velvia
50 film // 2 seconds at f45

Light is the primary tool of the landscape photographer.
Remember that you are photographing the light
illuminating the subject, and without the light there is
no photograph. Learning about the qualities of natural
light and how to use them effectively is a critical goal
for an aspiring landscape shooter. Waiting for light is an
outdoor photographer's avocation. Capturing this scene
with the right combination of sunset light and rare fog
was a once-in-a-lifetime gift, and also the payoff for four
hours of waiting in bitter cold. Perseverance, luck, good
light, being there and being prepared all came together.

↘

NATURAL LIGHT

THE QUALITIES OF NATURAL LIGHT

Midday sunlight
Useful for subjects with their own inherent colour. Shadows are deep, with little detail. Polarizer helpful. Best for some subjects: slot canyons, coral reefs.

Midday overcast
Useful to eliminate harsh shadows. Colour is white. Best when sun is highest overhead. Good for shooting moving water. Best for intimate subjects: forest interiors, portraits, moving water. 'New' films best for saturation and warmth.

Midday rainy
As above: scattering of light can produce high saturation.

Mottled lighting
Sun coming and going through clouds. Allows use of either sun or cloud depending on subject. Effective for reducing shadows in big scenics. Produces pleasing 'spotlights' in big scenics.

Canyon reflected light
Occurs when light is bounced from brightly lit canyon walls into shadow areas. Colour is very rich and warm, especially if the wall is fully lit and close. Useful for close-ups and intimate details.

Open shade
Normal shady area with no clouds. Light is very blue, especially in white subjects reflecting blue sky. Useful for bringing blues into scene. Combat blues with Tiffen 812 or warming filters.

Magic hour
Warm light (yellow) of the last or first hour of sunlit day. Shadows deep and effective for three dimensions with side lighting. Front lighting ineffective. Polarizing filters effective. GNDs may be needed.

Magic minute
Very warm (red, orange, violet) light. Subjects at only highest topography will be illuminated. GND often necessary. Important to scout for subjects or previsualize which subjects will be lit.

Stormlight or alpenglow
Spectacular lighting, usually short-lived. Occurs during magic minute or last few minutes of magic hour. Usually associated with bad weather. Often accompanied by red, rain, colourful clouds, lightning.

Chiaroscuro
Bright light contrasted with dark. Beautiful and dramatic effect. Usually dark clouds contrasted with bright landscape or vice versa.

Anti-sunset
Clouds lit by sunset light in the east, allowing landscape to be combined with dramatic sky. GND required (three-stop soft).

Normal sunset
More effective if reflective surface used for foreground – lake, snow and sand. Shooting into the sun is almost impossible in the southwest, easier where marine layer exists or during high humidity.

Post-sunset or pre-sunrise light
Landscape lit by residual sunlight bounced from upper atmosphere. Usually cool in colour. Red colour band sometimes occurs in the east or west. No shadows in landscape. Can be used as substitute for cloudy conditions. GND necessary.

Forest-fire light or severe atmospheric haze
Can produce excellent sun orb at sunset, also very warm and cool colours in same scene.

Moonrise
Usually best on the night before full moon, with post-sunset light. Moon will rise just to the right of pointing shadows. Consult internet moonrise timetables for exact times.

Night
Moonlit lighting not great. Best for star trails and lightning. Average lightning exposure (when thunder can be heard), lens wide open, two minutes with 400 ISO. Lightning colour is usually purple-violet.

SUMMER NIGHTS

The long duration of midnight summer light is a great resource, allowing amazing sunsets to last for hours. This image is also an example of my strategy to have an interesting subject to go with the good light. Luck was also involved, since rain had been coming down for weeks in this location.

→ **Kannesteinen Balanced Rock, Norway**
Toyo Field 45AII camera // Rodenstock 75mm lens // Kodak VS film // 8 seconds at f45

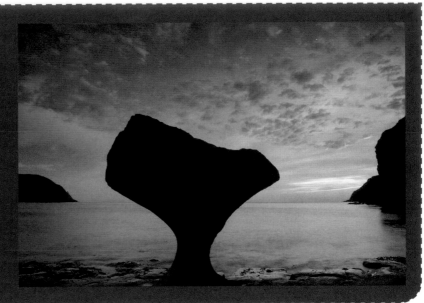

← **Cancha de Bochas, Ischigualasto Provincial Park, Argentina**
Toyo Field 45AII camera // Rodenstock 210mm lens // Kodak VS film // 1/4 second at f45

I've always sought out and enjoyed photographing strange and exotic landscapes. The world has so many amazing geological sites and landforms to experience and photograph that the possibilities are endless. Obviously, in desert regions your chances of getting good light are better than in more lush green areas of the globe. When travelling, I always budget more time for rainy areas than desert locales.

TIME OF DAY

Most great landscape photographs (but not all) have been made during the 'magic hour' – the periods just after sunrise and just before sunset. Some subjects, because of their orientation, are best lit at dawn and afterwards, while for others pre-sunset is the best time. Many times in my scouting and research I try to find subjects that are in a position to be lit by this first or last light.

Outside magic hour

A few subjects come to mind that do not work well at sunrise and sunset. If you're shooting a field of blue flowers, for example, pink light may actually pollute the colour you're trying to accentuate. Slot canyons of the south-west USA (or Jordan, Oman and Australia) tend to glow their brightest when the sun is directly overhead, and the blues of tropical oceans are also at their best at midday.

→ **Pinnacles Desert, Australia**
Toyo Field 45AII camera // Fuji Velvia 50 film // 8 seconds at f45 // 3-stop GND

Everyone is familiar with the normal sunset, but without an interesting silhouette or a highly reflective foreground, I find images of just the sunset to be boring, rarely rising above the level of a snapshot. Anti-sunsets are different. These events occur in the eastern sky, opposite the setting sun, or in the western sky in the morning. During this somewhat rare event, sunlight illuminates the subject and the amazing colours of the sky behind it at the same time. With a strong GND, the results can be stunning.

Pushing the envelope

Shooting at magic hour is done so much, and has become such a cliché, that I diligently try to shoot at other times of day. Overcast conditions help diminish the harshness of the midday sun, offering great times to shoot waterfalls and forest interiors, while any colourful subject can work during midday if care is taken to avoid the deep, dark shadows that occur at that time.

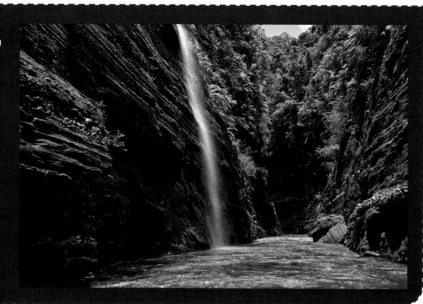

SLOT CANYON

These tropical slot canyons in Fiji worked well with overhead sun accentuating the green river water and lush vegetation. Lightroom's Fill Light feature was used to bring up shadow detail in the walls.

→ **Upper Navua River Conservation Area, Fiji**
Fuji FinePix S5Pro DSLR camera // Nikkor 18-200 lens at 31mm // ISO 400 // 1/400 second at f5.6 // No tripod

CLOUDS AND LIGHTING

Besides the landscape itself and the light from the sun, clouds have as much impact on landscape photography as practically any other element. Clouds can be used as subjects, adding an infinite variety of shapes and colours to the sky in a landscape photograph. Clouds also work as controllers of light, providing overcast conditions to eliminate harsh shadows, and allowing the sun to spotlight parts of the scene to provide drama and interest. I would much prefer working in the field on a day with good clouds as on a bald, blue-sky day with 'severe clear' conditions. With clouds around, many possibilities and surprises are possible that would never occur on a purely sunny day.

I constantly watch the nearby clouds when I'm working, keeping track of their type, movements and development. Becoming a student of cloud behaviour will have a positive impact on your landscape photography.

CLOUDSCAPES

My favourite clouds are the so-called buttermilk variety, patterned cumulus – as seen in this photograph of the Colorado River (below). I'm also drawn to the wonderful billowy fair-weather cumulus found in tropical locations. My least favourite are high clouds, which seem to suck the warmth out of 'magic hour' lighting, and are rarely photogenic subjects themselves.

BUTTERMILK CLOUDS

The rhythmic shapes of buttermilk clouds can add appeal to any landscape image. In this image, taken early in the morning, the beautiful patterns are reflected in the Colorado River.

↑ **Colorado River, Sorrel River Ranch, Utah**
Toyo Field 45AII camera // Rodenstock 75mm lens // Fuji Velvia 50 film // 1 second at f45 // 2-stop GND

SUN AND SHADOW

↑ **Grand Canyon National Park**
Toyo Field 45AII camera // Kodak VS film
// 1/4 second at f45

The beauty of clouds and sun can be seen at its best in big scenics found in places like the Grand Canyon. I try to wait for a good balance between light and dark, which also helps to create the illusion of three dimensions. My light meter assured me that the sunlit area of the scene and the unlit bright snow had the same EV, or exposure value, so contrast problems were nil and I could shoot away with impunity. If sun hit the snow and it was too bright, I waited for the sun to leave – part of the luxury of having a combination of sun and shadow.

CLOUDS AND SUN

With clouds and sun coming and going, a landscape photographer can have the best of both worlds in one shooting session. Need clouds to shoot a waterfall? Wait for it. Need spotlights of sun to liven up an otherwise overcast and boring scene? Wait for it. I call this kind of lighting 'mottled' light and I find it to be very beautiful, and especially effective for spotlighting some part of the landscape to give it added emphasis. Remember to make sure your meter is taking its reading from the brightly lit part of scene, or is averaging correctly, or your overall scene may be overexposed. Bracketing can also assure a good exposure if the scene is changing rapidly.

SHOOTING UNDER CLOUD COVER

Unless the rain is coming down in buckets (which is always a very difficult scenario for any landscape photographer), I can usually find some subject that will work well under cloud cover. My hero Eliot Porter, famous for his 'Intimate Landscapes' (see page 154), often had to explain to passers-by why he was photographing so much during overcast conditions. 'Wouldn't you like the sun better?' people would always ask, but his reply was always, 'I prefer this.' Why? Porter was mainly trying to avoid contrast, and since he was often shooting in the woods of Maine or the deep canyons of the south-west, he knew that any direct sunlight would detract from the shapes, colours and immaculate

compositions he was creating. Porter knew that any bright area in a photograph would immediately draw the eye, and he did not want random bright areas destroying his creations.

Take a walk in the woods on any sunny day and you'll see the problem – spots of sunlight hit the trees and the ground here and there, and an overall composition of the forest under these lighting conditions will confuse the eye, sending it on a wild goose chase through the photograph.

FOREST FLOWERS

In this image, a riotous bloom of forest flowers colours the floor of the Appalachian Mountains in America. With the sun under a deep cloud mass, there are no 'hotspots' to ruin my composition and lead the eye out of the near/far composition of flowers and woodland.

← **Great Smoky Mountains National Park, Tennessee**
Toyo Field 45All camera // Fuji Velvia film // 2 seconds at f45

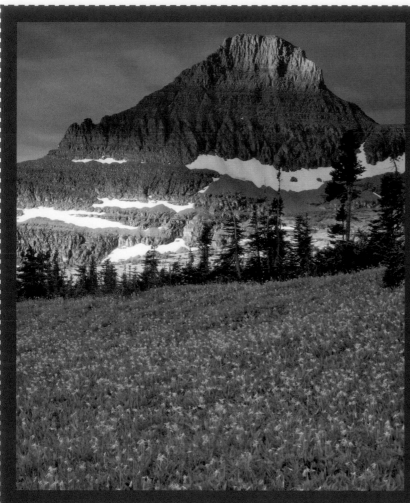

MOUNTAIN GLOW

Morning stormlight can produce a beautiful glow, as in this shot of Reynolds Mountain. The main components of the image (besides the spectacular fleeting stormlight) were an early wake-up call and the all-important GND filter.

← Glacier National Park, Rocky Mountains, Montana
Toyo Field 45AII camera // Schneider 120mm lens // Fuji Velvia 50 film // 2 seconds at f45 // 3-stop GND

STORMLIGHT

Chasing the ephemeral beauty of stormlight is a risky enterprise. Many times photographers will have little to show for their efforts, as clouds cover the waning sun and provide no spectacular alpenglow or stormlight. As often as I've met with failure, I still keep trying to capture the rare, beautiful and dramatic light associated with storms. As my friend David Muench says, 'Bad weather means good pictures.'

Most often, stormlight will appear at the very denouement or beginning of the day, as sunlight streams from below dark clouds. If the clouds are black or blue enough, the contrast of colour and light produces the chiaroscuro effect – possibly the most dramatic sky event of all.

FOG AND FOUL WEATHER

Fog and the landscape produce an ethereal, mysterious combination. When fog is at play among monumental features of the Earth, I find photography to be at its most enticing. Fog can appear within many weather conditions, but is most often seen in mountainous areas when a storm is starting to break up, or during normally fair periods on still, humid mornings. Don't forget the wonderful combinations of fog, trees and sunlight, usually an early morning phenomenon.

BACKLIT FOG

Sometimes the best fog images can be made from an aeroplane. In this backlit image (right), I used the aeroplane wing to block the direct sun and avoid flare. Although the image is fairly monochromatic, there is some warmth from the sunrise light. I had arranged the flight the night before, planning to shoot the lakes of the region from the air, and happened upon this lucky fog event. Our takeoff time was 4:00am.

→ **Voyageurs National Park, Minnesota**
Olympus 35mm camera // 50mm lens // Kodachrome 64 film // 1/1.000 second at f1.8

↑ **North Window, Arches National Park, Utah**
Toyo Field 45AII camera // Fuji Velvia 50 film // 1 second at f32 //
Tiffen Warm Polarizer filter

CHASING RAINBOWS

I've always had a thing for rainbows. Maybe it's like seeing a rare wild animal that can appear at any time, or stay hidden for years. But as with sunsets, a rainbow by itself doesn't excite me; I'm more interested in a rainbow as part of an overall great scene. A great rainbow can elevate a good scene to mythic status.

Although finding most rainbows is just luck, certain places and conditions are better than others for rainbow hunting. Rain in desert regions that is almost always spotty and short-lived is great for rainbow chasers, as is the shower/sun regime often found in tropical islands and in Ireland, where rainbows seem to be as common as ancient castles.

I always use a polarizing filter to brighten and saturate the rainbow, but be careful. As you wipe raindrops from the filter, you might accidentally turn it, erasing the rainbow altogether. Remember, too, that rainbows are only going to happen when the sun is low on the horizon – early in the morning and late in the day.

04

COMPOSITION FOR LANDSCAPE

Lake Powell Channels, Glen Canyon, Utah
Canon EOS-1DS Mark III camera // 24–105mm USM
zoom lens at 47mm // 1/4000 second at f4

Nature's patterns are infinite, and good landscape
photography exploits these beautiful forms as much as
possible. Abstract patterns are some of my favourite
subjects. I love the idea of turning something real
and concrete – in this case rock and water – into
something unusual and unexpected. As I look for
subjects, pattern is a key element in my visual sorting
process. Compositionally, I also like the idea of filling
the frame with pattern – there's no wasted space.

THE RULE OF THIRDS

The rule of thirds is a compositional regimen brought over to photography from painting and drawing. To improve your compositional IQ, I suggest looking at painting as much as photography. I believe that visually studying good art on a regular basis is one of the best paths towards creating better compositions of your own.

Since the brain seems to prefer odd-numbered compositional elements over even ones, the rule of thirds simply states that dividing the photographic composition into thirds (a grid of nine squares), and placing the most important subject element at the intersections of the lines will always keep the main subject from being centred in the middle of the photograph. Most viewers find it disturbing and unnatural to see the main subject in the centre of the frame. The rule of thirds also encourages artists and photographers to place any layers of the photograph – such as foreground, middle ground and background – along the two lines that divide the image into thirds.

Remember that all these compositional rules are made to be broken, and sometimes blatant disregard of the rules can produce excellent results.

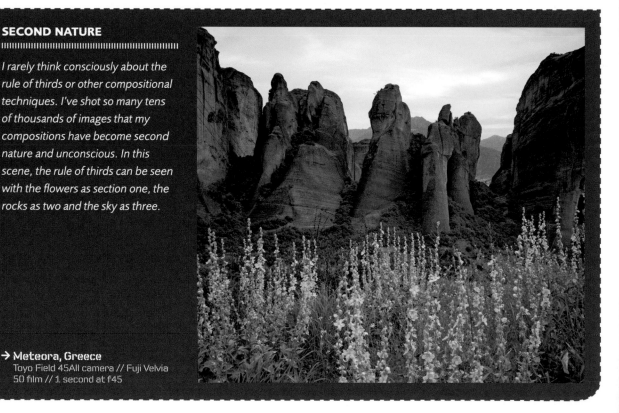

SECOND NATURE

I rarely think consciously about the rule of thirds or other compositional techniques. I've shot so many tens of thousands of images that my compositions have become second nature and unconscious. In this scene, the rule of thirds can be seen with the flowers as section one, the rocks as two and the sky as three.

→ **Meteora, Greece**
Toyo Field 45All camera // Fuji Velvia 50 film // 1 second at f45

PATTERN AND TEXTURE

The natural world is full of incredible patterns and textures, and the number of subjects it offers is infinite. Although pattern and texture can form a significant part of any landscape photograph, many of the photographs in this genre are medium close-ups, smaller parts of the overall landscape that most people might pass by. This style of landscape photography also provides a good opportunity to experiment with more abstract imagery. I love to produce renditions of the natural world that are not readily identifiable, and I find that the public responds as positively to these pictures as they do to my more 'normal' work.

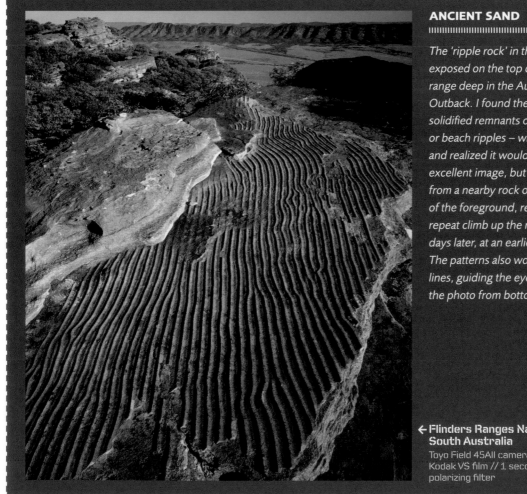

ANCIENT SAND

The 'ripple rock' in this image is exposed on the top of a mountain range deep in the Australian Outback. I found the rock – the solidified remnants of ancient sand or beach ripples – while hiking and realized it would make an excellent image, but a shadow from a nearby rock obscured part of the foreground, requiring a repeat climb up the mountain a few days later, at an earlier time of day. The patterns also work as lead-in lines, guiding the eye through the photo from bottom to top.

← Flinders Ranges National Park, South Australia
Toyo Field 45AII camera // 75mm lens // Kodak VS film // 1 second at f45 // Warm polarizing filter

LEAD-IN LINES

Lead-in lines are one of the most effective tools for creating a successful composition. The idea is simple: find a foreground made up of graphic lines that lead the viewer's eyes into the photo, with the 'trip' usually culminating in the main subject. A wide-angle lens is usually used with lead-in lines to provide the space to include all the elements, and vertical or portrait format is often the most effective format to make this trick work. Lead-in lines also work to provide perspective and three dimensions in a photograph, angling towards the horizon and growing smaller.

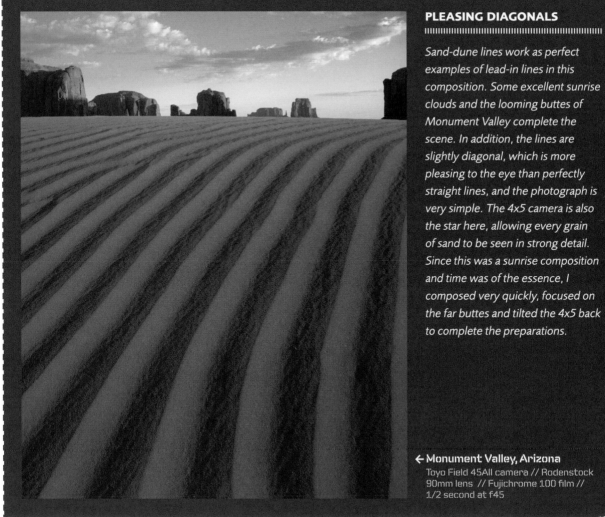

PLEASING DIAGONALS

Sand-dune lines work as perfect examples of lead-in lines in this composition. Some excellent sunrise clouds and the looming buttes of Monument Valley complete the scene. In addition, the lines are slightly diagonal, which is more pleasing to the eye than perfectly straight lines, and the photograph is very simple. The 4x5 camera is also the star here, allowing every grain of sand to be seen in strong detail. Since this was a sunrise composition and time was of the essence, I composed very quickly, focused on the far buttes and tilted the 4x5 back to complete the preparations.

← **Monument Valley, Arizona**
Toyo Field 45AII camera // Rodenstock 90mm lens // Fujichrome 100 film // 1/2 second at f45

DEPTH OF FIELD AND COMPOSITION

Though selective focus may be used occasionally, most landscape photographers usually strive for the maximum possible depth of field in their imagery. Deep focus is most evident in near/far compositions, where depth of field extends from a close, carefully selected foreground to a distant subject, all of which remains impeccably in focus. Lead-in lines, discussed earlier, can be an important part of this type of composition, but near/far scenes can also work well as compositions with other shapes and subjects in the foreground. Photographer David Muench has been a consistent popularizer of this near/far paradigm, although the style can also be seen in the work of Ansel Adams, and many *National Geographic* photographers who came from photojournalistic backgrounds and who started to make use of the first wide-angle 35mm lenses for landscape photography.

Finding a great near/far combo can be exciting. I like to fill the bottom of this type of composition (which works best as a vertical, but can be crunched into the horizontal framework) with something colourful, interesting or beautiful in form or texture, and it's nice to have as majestic a backdrop as possible.

DEEP FOCUS

The depth of field necessary for this composition can only be attained by a 35mm camera with a wide-angle lens and the aperture stopped all the way down, or with a 4x5 with the back tilted backwards and also stopped down. Simplicity has been attained by eliminating the middle ground completely, leaving just the lupins and waterfall. As technology advances, 35mm lens makers have been producing wide-angle lenses that focus closer and closer, while still preserving deep focus. Helicon Focus software allows maximum depth of field with a 35mm DSLR – matching that possible with 4x5 or 35mm swing-and-tilt cameras.

↓ **Lauterbrunnen Valley, Switzerland**
Toyo Field 45AII camera // Fuji Velvia 50 film //
2 seconds at f45

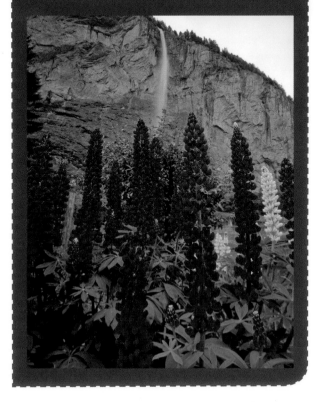

↘

FRAMES WITHIN FRAMES

One of my favourite compositional devices is framing. Though some may see it as a cliché, I see it as a time-honoured technique, and I'm always looking for ways to use the trick. There's no better way to focus the wandering eye of the modern human than forcing that attention into the space where you want it to go. Nature provides a large number of possible frames, including tree leaves, natural arches and openings, shafts of light and blocks of darkness.

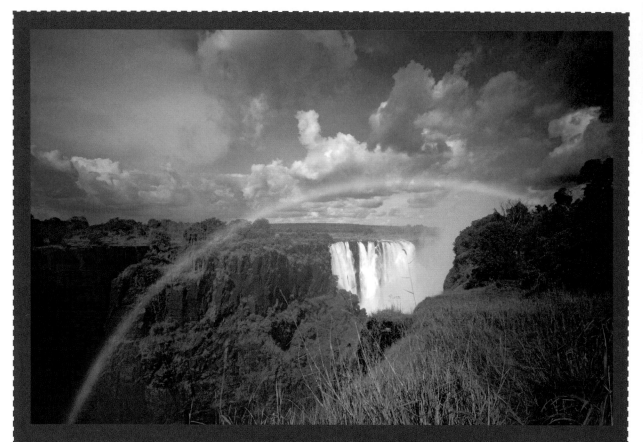

RAINBOW FRAME

Framing Victoria Falls with a rainbow in this scene was pure luck, as the position of the rainbow will change over the course of a day and over the course of the year. I used a warm polarizer to accentuate the rainbow. Guards at the National Park were not going to let me in with my 4x5 gear, but eventually relented.

↑ **Victoria Falls National Park, Zimbabwe**
Toyo Field 45AII camera // Nikkor 75mm lens // Fuji Velvia film // 1/2 second at f45

↘ INCLUDING PEOPLE

I generally only include people in my landscape images to create a sense of scale. If people have a bigger presence, we're into a different category of image – lifestyle or outdoor adventure. With a 4x5 and the usual long exposures, it's important to keep your model from moving, and I try to avoid 'butt' shots with the model's rear end facing towards me. With very distant human subjects, it's sometimes necessary to have the model move their legs apart so that the human form can be readily recognized.

MERE MORTAL

I placed my hiking companion near the lightest part of this giant cave opening to accentuate the huge size of the cave and the small size of a man. Since the human shape doesn't mimic any of the other patterns of the entrance, it's easy to discern the silhouette as a human form, even though the figure is very small.

↑ Hiker, Leviathan Cave, Nevada
Toyo Field 45All camera // Schneider
90mm lens // Kodak Ektachrome 64
film // 30 seconds at f45

COMPLEMENTARY COLOURS AND TROUBLESOME WHITES

In general, colours that are opposite to each other on the colour wheel are dynamic and usually pleasing to the eye in combination. The blues of snow and reds of sandstone in my part of the world always look good together as opposites on the wheel. I use colours that are close together on the wheel less often, but I do like green and yellow together, and I try to find this combination whenever possible. Much of this is personal preference, and you may find yourself having an emotional reaction to the colours you see in nature rather than an intellectual one. Also, your tastes may change over time or from day to day. Some days I'm drawn to pastels and harmonious colours, while on other days I feel like splashing through the whole wheel.

Whites or bright areas are sometimes troublesome in compositions, because it seems the eye is drawn right to them in any image. Sometimes you may want this to happen, but other times it may work against you, pushing the viewer's eyes away from where you want them to go. This is one reason I despise white skies and will do just about anything to avoid them. I don't mean cumulus clouds, because they are usually tempered by blues and stand as a subject themselves, but featureless high clouds.

BLUE ANCHOR

Though this scene is dominated by white, the intense blues of the wild flowers at the bottom keep the eye in the image – an example of a use of white that works. Ironically, a smaller area of white might be more obtrusive and more of an 'eye magnet' than the large expanse.

← **Swiss Alps**
Toyo Field 45AII camera // Rodenstock 75mm lens // Fuji 50 film // 1/4 second at F45 // Polarizing filter and 2-stop GND on snow

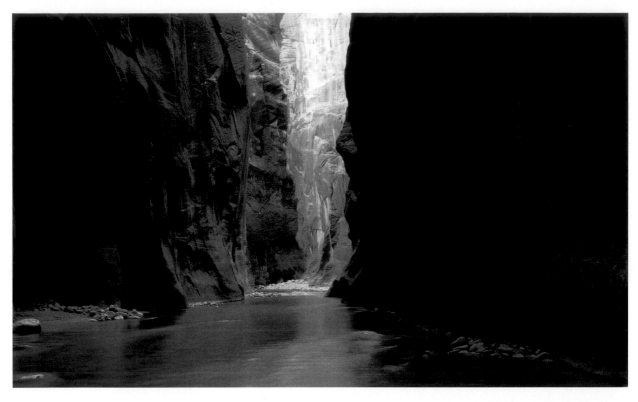

↑ **Reflected slot canyon light, Zion National Park, Utah**
Toyo Field 45AII camera // Rodenstock 180mm lens // Kodak VS film //
30 seconds at f45

OTHER COMPOSITION TECHNIQUES

Diagonal lines

Diagonal lines are very pleasing to the eye, and
divide a rectangular shape in a psychologically
pleasing way. I look for diagonals wherever I can
find them, and, if possible, create them by turning
the camera slightly on its side.

S-curves

S-curves are another graphically interesting shape
that sometimes occurs in nature. Though much
harder to find than diagonals, it's possible to find
S-curves in forest branches and in the turns of
streams and rivers. I discovered these lupins (right)
following the S-curving course of a stream in New
Zealand. I shot from a small hill and condensed the
distance with a long focal-length lens.

↘ **Lupins in Southern Alps, New Zealand**
Fuji FinePix S5Pro DSLR camera // Nikkor 80-200 lens
at 200mm // f22

PREPARING FOR FIELDWORK

I take three great pleasures in photography. One is seeing my work in print, which is always a thrill. Another is opening a box of film fresh from the lab, or downloading a batch of new digital images.

But the best part of landscape photography is being in the field. I could give up photography tomorrow, but not hiking and exploring in the outdoors. I also believe that any successful images I have made stem from this love of the natural world. If you don't have it, your chances of succeeding at outdoor nature photography are immediately diminished. However, if you do choose to pursue landscape photography in a serious way, you will be rewarded in ways you could never have imagined – even taking into account the heat, cold, rain and bugs.

Preparing at home

Besides cleaning your equipment and ensuring that it's in good working order, there are several things you can do at home to prepare for your shoot, whether it's for a month or just an evening.

I check the projected weather constantly on television and the internet before heading out, to make sure I'll have the sky conditions I need and that wind won't be a major problem. In winter this is important, as I track snowstorms to try to work myself into them (I arrive before the storm and leave after, to avoid winter driving conditions). For the rest of the year I use information online to check on wildflower blooms, snowmelt runoff that might create monumental waterfalls, autumn colour forecasts, drought conditions that would make me want to avoid an area, and long range weather forecasts. Sadly, in this day and age, security and health concerns are also an important consideration in many beautiful parts of the world.

SAFETY FIRST

Before I visited Yasur Volcano on Vanuatu, I tried to ascertain how safe photographing and viewing the volcano really was. Although I couldn't get any guarantees, it seemed that although there was some danger, the chances were small that I'd have any trouble. I was also able to book lodging and guides online.

→ **Yasur Volcano, Vanuatu**
Pentax 6x7 camera // 55mm lens //
Fuji 400F film // 2 minutes at f8

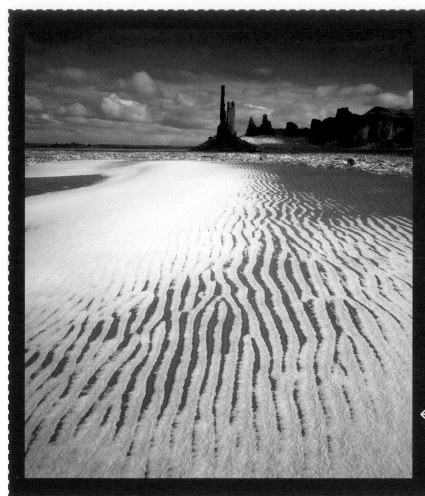

Some locations have areas that are off limits to the general public, but you may allowed to enter if you're accompanied by an official guide. I always work with a Navajo guide at Monument Valley; it's the only way to visit areas like these sand dunes.

← **Monument Valley Tribal Park, Arizona**
Toyo Field 45All camera // Schneider 120mm lens // Kodak VS film // 1/2 second at f45 // Warm polarizing filter

Do you need a guide?

In certain places, such as Monument Valley in the United States, local guides are required if you wish to move about freely to take photographs. Even in other areas, it might just save you a lot of time and effort to hire a photography guide. Most places in America known for being photography hotspots now have experienced locals who will take you out into the field at sunrise and sunset to visit their favourite haunts. I've hired guides in China, Cambodia, Egypt and many other locales. I have also joined photo tours overseas when the logistics and difficulty of photographing alone (in India, for example) are just too much. Though I would always prefer to be on my own and in complete control of travel schedules, sometimes it's more productive to have help.

Using travel books

Travel and photography guidebooks are some of my favourite armchair reading. I especially like the heavily illustrated kind that give me some idea of the photographic potential of places I might want to go. Don't rely on these books too much, however, as I almost always find amazing scenery that's not in the book.

PHOTOGRAPHY GUIDEBOOKS

Recently, a new kind of travel book has appeared that is aimed specifically at photographers. There are several covering the south-west, where I live, and I've seen volumes covering the American West Coast states and the Yellowstone area of the Rockies. Some of the books would be mostly useful for first-time visitors, while others go into great depth with multi-volume sets covering certain areas. Before long, I'm sure every part of the globe will be covered.

Many guidebooks even give GPS coordinates to the locations they feature – another reason to own and use one of these useful devices (see page 87). But again, remember not to be too tied to guidebooks. There are many fantastic locations not mentioned in any guidebook, so keep your eyes open for postcards, tourist literature and local photo books for more ideas.

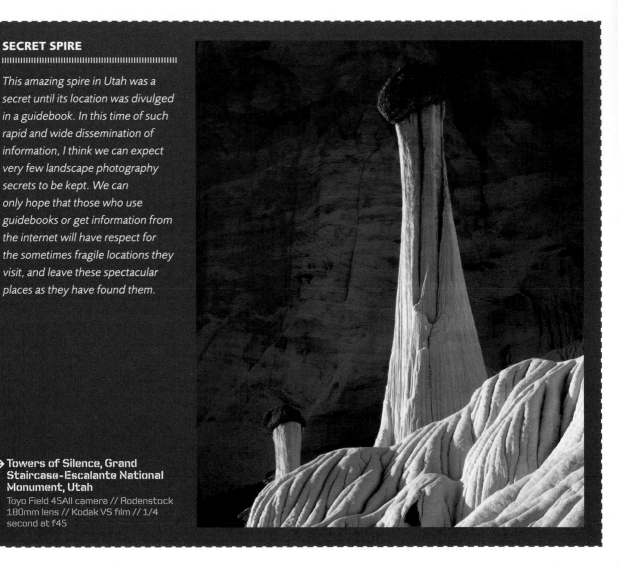

SECRET SPIRE

This amazing spire in Utah was a secret until its location was divulged in a guidebook. In this time of such rapid and wide dissemination of information, I think we can expect very few landscape photography secrets to be kept. We can only hope that those who use guidebooks or get information from the internet will have respect for the sometimes fragile locations they visit, and leave these spectacular places as they have found them.

→ Towers of Silence, Grand Staircase-Escalante National Monument, Utah
Toyo Field 45AII camera // Rodenstock 180mm lens // Kodak VS film // 1/4 second at f45

↑ Bryce Canyon National Park, Utah
Toyo Field 45All camera // Rodenstock 75mm lens // 2 seconds at f45

NEW PERSPECTIVE

Many of my most successful images come from actively scouting locations. Since I'm always trying to find a new slant on common subjects, I was excited to find this aspen tree on the rim of Bryce Canyon in Utah. Although I could see that it was several days away from peak colour, I knew that it would make a great sunrise foreground. I returned several days later, and then visited the tree every day at dawn for three days to get peak colour and a great sunrise. Amazingly, there were a large number of other serious photographers at the viewpoint, but none were interested in my gorgeous tree. They all wanted the standard Bryce Canyon shot, not something new and different.

SCOUTING

Though cyber-scouting (see pages 86-7) and previsualization using maps can be useful, there is no substitute for seeing a location with your own eyes. Scouting a shot can range from looking a place over for a few minutes before you begin working, to returning days, months or years later to get the shot you want.

Consider where to set up, what lenses to bring (if the hike is long you may be able to leave some lenses you don't plan to use at home) and what time of day and year is best. Scouting is a great activity for the midday doldrums or for rainy days that make photography impossible. Since you will be arriving at most sunrise locations when it is still dark, scouting is always particularly important for sunrise shots. Showing up before dawn and trying to find a shot in the dark is usually a recipe for disaster.

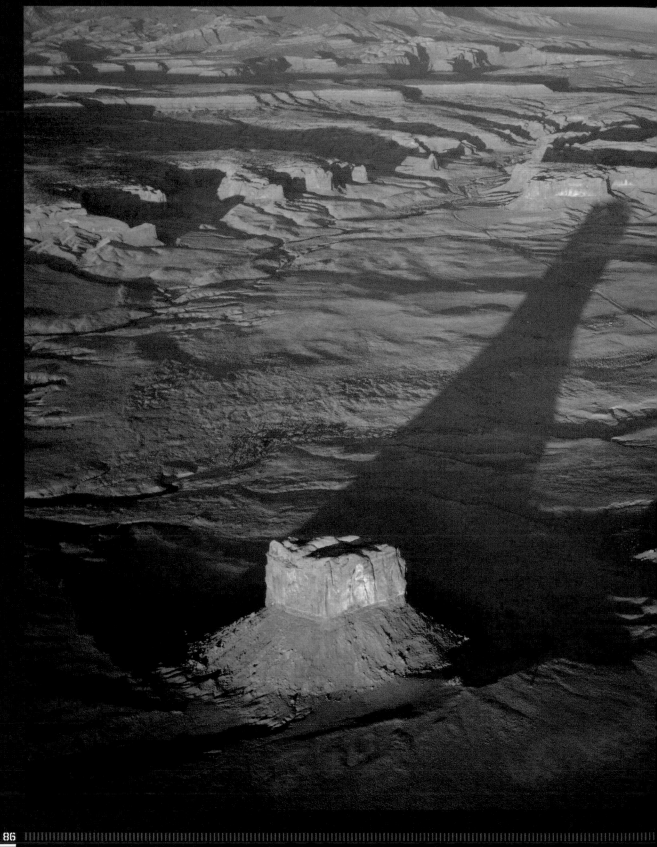

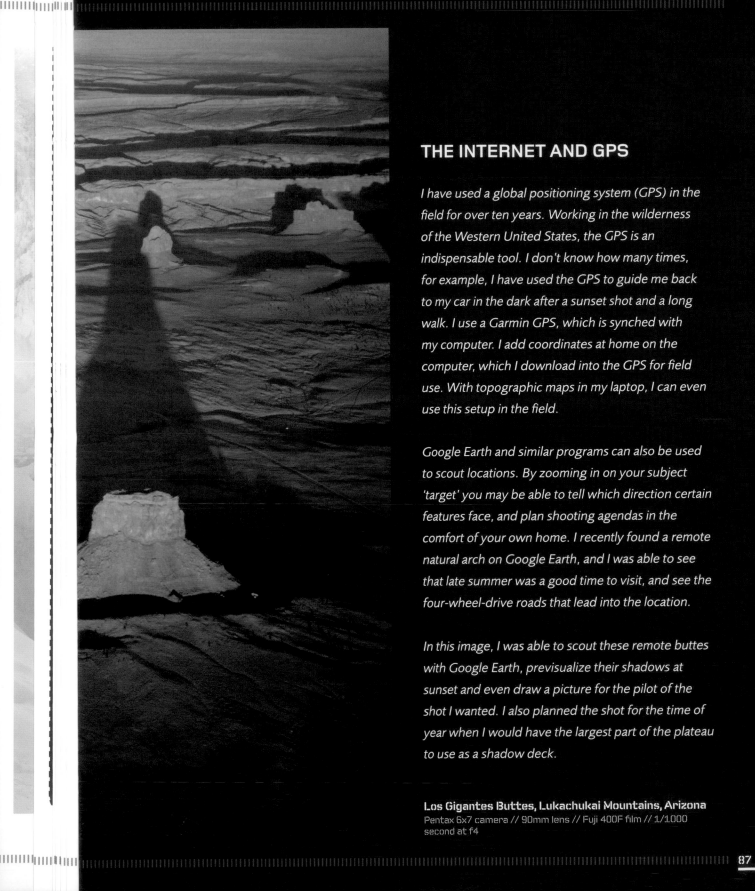

THE INTERNET AND GPS

I have used a global positioning system (GPS) in the field for over ten years. Working in the wilderness of the Western United States, the GPS is an indispensable tool. I don't know how many times, for example, I have used the GPS to guide me back to my car in the dark after a sunset shot and a long walk. I use a Garmin GPS, which is synched with my computer. I add coordinates at home on the computer, which I download into the GPS for field use. With topographic maps in my laptop, I can even use this setup in the field.

Google Earth and similar programs can also be used to scout locations. By zooming in on your subject 'target' you may be able to tell which direction certain features face, and plan shooting agendas in the comfort of your own home. I recently found a remote natural arch on Google Earth, and I was able to see that late summer was a good time to visit, and see the four-wheel-drive roads that lead into the location.

In this image, I was able to scout these remote buttes with Google Earth, previsualize their shadows at sunset and even draw a picture for the pilot of the shot I wanted. I also planned the shot for the time of year when I would have the largest part of the plateau to use as a shadow deck.

Los Gigantes Buttes, Lukachukai Mountains, Arizona
Pentax 6x7 camera // 90mm lens // Fuji 400F film // 1/1,000 second at f4

↘

SPRING

Most nature photographers I know make spring and autumn pilgrimages to favoured locales to shoot these particularly beloved seasons. After winter's sometimes harsh conditions, many landscape photographers are eager to get out in the field as nature begins its yearly cycle anew.

Shoulder seasons

I find including two seasons in one image tells a very interesting story, so I'm always looking for new flowers covered in snow, or green valleys and wild flower fields beneath heavily snow-laden peaks.

Wild flowers and waterfalls

Wildflowers can begin very early in the spring, often in desert fields or in forest understories before the trees have fully leafed out. Another favourite spring subject is waterfalls, which are apt to be most vigorous as temperatures rise and snow melts.

↘ **Yosemite National Park, California**
Toyo Field 45All camera // 360mm lens //
Fuji Velvia 50 film // 1 second at f32

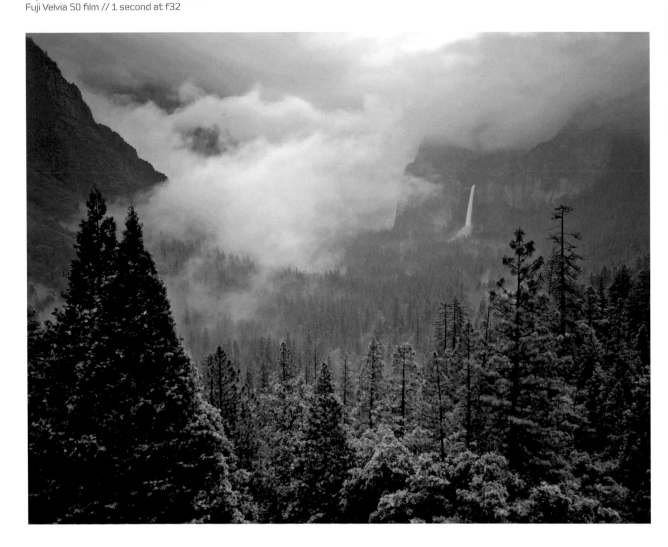

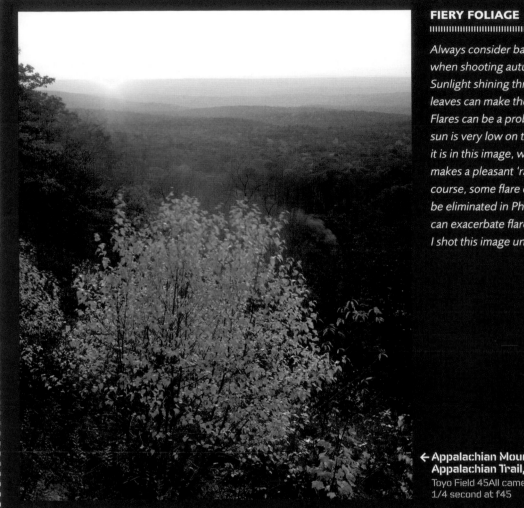

FIERY FOLIAGE

Always consider backlit images when shooting autumn colour. Sunlight shining through the thin leaves can make them glow like fire. Flares can be a problem unless the sun is very low on the horizon – as it is in this image, where it actually makes a pleasant 'ray' effect. Of course, some flare effects can also be eliminated in Photoshop. Filters can exacerbate flare problems, so I shot this image unfiltered.

← Appalachian Mountains, near Appalachian Trail, New Jersey
Toyo Field 45All camera // Fuji Velvia film // 1/4 second at f45

AUTUMN

With cool temperatures and riotous leaf colours, autumn is perhaps the most photogenic outdoor season. It's also a time when landscape photographers have to compete with the general public for lodging, campsites, parking, and even, at times, a spot to set up a tripod. As with wild flowers in spring, there are a large number of websites to obtain information about the progression of autumn colours and forecasts for peak periods. While everyone loves to shoot beautiful leaves when they are still clinging to trees, don't forget that the leaves are also gorgeous after they've fallen.

DIGITAL ETHICS

With the almost miraculous control over the image that digital technology offers, some photographers feel that the purity and honesty of landscape photography is in jeopardy. I have a fairly liberal attitude to this issue. Looking at the founding fathers of our art form, I see Ansel Adams, who considered the darkroom to be the place where he could creatively control his vision of the natural world. For him, the negative was the 'score' and the print the 'performance'. Eliot Porter followed the same philosophy, using filters extensively and exerting complete control over his dye-transfer colour prints.

As a frustrated painter, my goal has been to please myself, rather than try to match some prescribed definition of what an outdoor image should look like. So far, my digital renditions have been widely accepted by both the public and photo editors. So, all these controls allow us to pursue our individual vision even more, satisfy our creative itch better, fix problems that were previously unfixable and produce beautiful work that, in some cases, was not even possible before.

On the other hand, one of the sad things about the digital age is that an image like this, which was created only with natural light and no manipulation, would probably be thought to be 'doctored' in some way digitally. Considering the horrendous flight I took to the site, the grief I got from the locals ('No one is allowed here in the morning'), the chance of getting malaria, the rabid wild dogs and the pre-dawn wake-up call, I would like credit for getting the image, untouched, on film.

← **Abu Simbel, Egypt**
Toyo Field 45AII camera // Fuji Velvia 50 film // 1/2 second at f32

FIRST STEPS WITH LIGHTROOM

We are definitely living in an exciting period for photography with the advent of the tools available in Lightroom, Photoshop and other programs. Lightroom is sometimes billed as a digital darkroom, but I feel this is a bit of a misnomer. With film landscape imagery, the developing stage, usually using E-6 processing, affords no creativity. The photographer exposes the film, the lab develops it – end of story.

The Develop feature of Lightroom does things that no lab could ever do, controlling colour, white balance, blacks, contrast and many other components in non-destructive ways. Another major component of Lightroom is its devotion to metadata, the information that is now added to all digital images: keywords, extensive captions and information just for the photographer – photo statistics, histograms, colour saturation, luminance, hue, tone curves, and noise and sharpening.

Getting started

Your first task in Lightroom, besides perhaps test-driving some of its features, will be to download your images into the Library section. Lightroom was made for photographers who might be shooting hundreds of digital images a day, but it will work just as well if you are shooting far fewer. If we compare Lightroom to analogue photography, the Library section would be analogous to the process of looking at and editing images on the light table, and then after development, allocating them to files and folders where they can be easily retrieved.

Downloading from your camera

Downloading images from your digital camera is a fairly easy process with Lightroom, and only requires a cable that connects the camera to a port on your computer. In the Library module, click Import, and your images will begin to download to your main library or into a specific folder you have assigned. Remember to delete all the old images from your card after you have imported them, or you'll download the images twice; and don't forget to be sure your camera battery is charged sufficiently to work through the entire download, especially if it's a long one.

SHADOW DETAIL

These unusual mineral formations were lit by the morning sun, and since they were as white as snow, holding shadow and highlight detail was a problem. I was able to see on my histogram that none of the highlights were clipped, so I simply added fill light to open the shadows. The Fill Light control in Adobe Lightroom is designed to perform a similar function and can help reveal hidden shadow detail in an image.

← **Mineral formations, Utah**
Fuji FinePix S5Pro DSLR camera // 18-200
lens at 18mm // f16

Both Lightroom and the camera must be running for a successful download. Check the instructions that came with your camera to make sure you're doing it right, but it's a simple procedure with most recent DSLRs. Card readers, which require a small investment, are also a good idea. These small devices don't require your camera to be involved and don't run on batteries.

Presets

Lightroom has many preset controls that can process large batches of images automatically. These are great for wedding and commercial photographers, but I prefer to assess exposure and colour one image at a time, just as I would with transparencies. You can preset the addition of photographer credits to your images, which will save time, but I don't like to add the year of creation because I feel some photo buyers might be prejudiced against older images. Since most landscape imagery is timeless, I think the date of creation of an image is my business.

EDITING IN LIGHTROOM

With all the new images from a shoot imported and displayed as thumbnails, I begin editing for exposure and content. I try to be as ruthless as I would be in editing my film, deleting obvious over- and underexposures, and checking problems like white balance, sharpness and composition.

Remember that Lightroom can salvage images that are 3-4 stops over- or underexposed, so just because an image is very badly exposed does not mean it's lost. This is done in Lightroom's Develop module – just use the Develop slider to fix these images. Lightroom gives you a full 8 stops of control over your exposure, salvaging images that are totally blown out, and those that are almost black.

RAW files

RAW images tend to be rather dull compared to film renditions and need the help of colour saturation, vibrance and contrast controls to reach their full potential, or to look like their equivalent in Kodak VS or Velvia film. Many times, having shot both film and digital images, I will use my film copy as a guide for my work with the Lightroom Develop controls. For beginners, this is a great way to experiment with the Lightroom controls and to get closer to the digital rendition you want. This is especially true if you are happy with film's highly saturated version of reality.

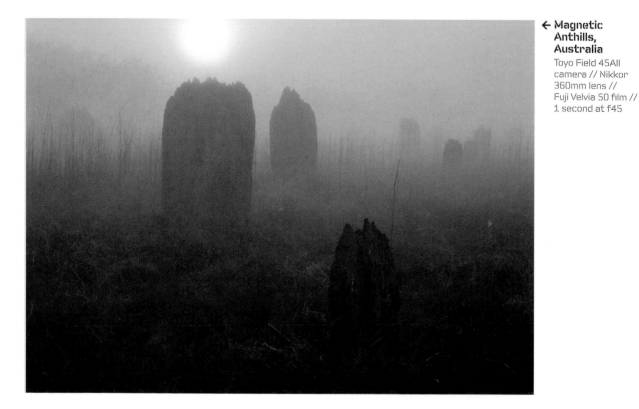

← **Magnetic Anthills, Australia**
Toyo Field 45AII camera // Nikkor 360mm lens // Fuji Velvia 50 film // 1 second at f45

DODGING AND BURNING IN LIGHTROOM

If you have taken an exposure in which the highlights are horribly clipped or overexposed (the histogram can show these areas and warn you about them), you can make some amazing exposure corrections with Lightroom's Brightness and Contrast sliders, or the easy-to-use Tone Curve controls. The Fill Light control is nothing short of miraculous.

In the image below, even with exposure bracketing and using GND filters, my foreground of shaded snowy trees was underexposed. I knew the open-shaded area would go very blue, which I wanted. A quick click on the Fill Light slider brought this area up to an acceptable exposure without affecting the sunlight mountain exposure

at all. This is as close to simple digital dodging and burning as I've seen, and it did not require merging multiple exposures (see page 129). I also like the way the subjects in fill flash are rendered; the colours are pleasing and there's a certain naturalness to the tool that matches the way the human eye sees disparate light values.

↑ Uinta Mountains, Utah
Fuji FinePix S5Pro DSLR camera // 18mm lens // 1/2 second at f22

RISK OF EXPOSURE

Sometimes, when shooting with both 4x5 and 35mm digital cameras under rapidly changing conditions, I have to make a choice: which format do I use? My present strategy is to get both if I can, but sometimes in the hasty switch between cameras, I make mistakes. The original capture of the mountain image shown here was about 2 stops too dark, but using the Exposure and Fill Light controls in Lightroom, I was able to produce a correctly exposed image.

WHITE BALANCE

I always use the Outdoor Landscape white-balance setting on my Canon camera, changing it only for interior work, but I know some photographers who shoot outdoors in sunlight with the white balance on the Cloudy setting to achieve a warmer overall tone. In Lightroom, changing from the As Shot setting, which is my default, to the Cloudy setting does sometimes produce a better image, but this is a matter of taste. I much prefer controlling colour with Lightroom's Vibrance and Saturation controls.

Having said that, in the image of the Great Salt Lake shore in Utah shown below, I preferred the Daylight setting in Lightroom's White Balance control to the As Shot setting coming from my camera. The difference is subtle, but shows how tweaking white-balance controls can sometimes have a pleasant outcome.

↓ **Great Salt Lake shore, Utah**
Fuji FinePix S5Pro DSLR camera // Nikkor 18-200mm lens at 34mm // ISO 100 // 1/8 second at f29

VIBRANCE AND SATURATION

A common problem with using the Saturation control in Photoshop or Lightroom is the danger of boosting light areas of the image to a blown-out or clipping level. The new control, called Vibrance, allows boosting of colour saturation without this danger. Vibrance also tends to increase the subtler colours in the image more than the already strong hues. You will have to experiment with both Vibrance and Saturation to see what works best with a particular image. Again, I find that using RAW images usually requires some work with the Saturation or Vibrance controls, unless you are a fan of subtle or monochromatic colours, although some images may need very little change. Remember that with the Lightroom controls you can always undo these changes and go back to the original RAW image, which gives you considerable peace of mind. Also, keep an eye on your histogram when using the Saturation slider to avoid clipping.

Shot on 6x7 film with very little saturation, the image below was reworked in Lightroom with the Vibrance slider. The result, showing the blue glacial colour of the water, was more like reality. A GND filter was used on the sunset light covering the volcano.

Osorno Volcano, Chile
Pentax 6x7 camera // Pentax 55 lens //
Kodak Ektachrome film // 2 seconds at f22

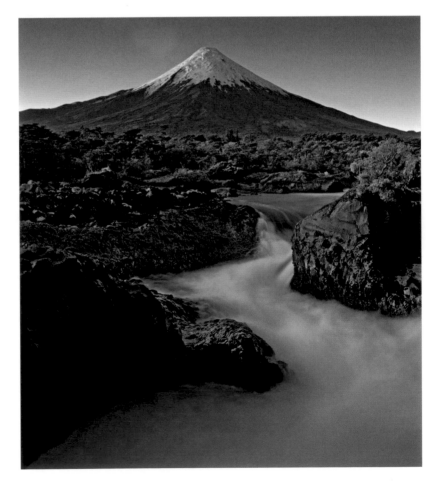

My first experience with digital photography and Lightroom was outdoors, but not landscape photography. I was convinced by my niece to take photographs of her wedding, a job for which I have little aptitude or experience. The amazing exposure controls in Lightroom saved my bacon. I had many scenes outdoors in harsh sunlight, and white dresses combined with black tuxedos created horrendous contrast problems. With virtually no Lightroom experience, I was able to salvage every one of the more than 200 images I took in less than two hours.

Part of the reason for my success was being lucky enough to know I should be shooting in RAW, which allows exposure corrections of 4 stops in both directions. I have been amazed at how well this control works with bad exposures.

Lightroom histograms have an added bonus. As you work with exposure controls like Fill Light, you can see the graph moving away from the left wall as a consequence of the change in underexposed areas. If you've oversaturated and clipped some highlights on the right side, you can easily see how far to back off in the histogram to remove the clip.

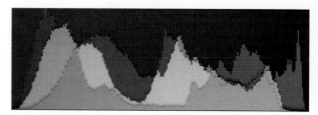

↗ This histogram comes from an image that has had its exposure corrected in Adobe Lightroom. Note how the gray portion of the graph does not touch either the right or left wall.

NOISE AND SHARPENING

Noise
Noise is a troublesome 'pollution' that appears on some digital images, but I have yet to see any artefact in my own images that I could call noise. The fact that most nature photographers, including myself, are shooting at low ISOs tends to mitigate the problem. If you do have a noise problem, which is somewhat analogous to grain in film, the Develop module of Lightroom has noise-reduction sliders that may help diminish the noise slightly. But since you will be shooting outdoors, and always with a tripod, noise should not be a major worry for landscape photography.

Sharpening
Early versions of Lightroom sharpened every image by 25 points automatically. This minor sharpening helped get rid of the digital 'look' and provided a more natural appearance to images. Since landscape photographers are not usually concerned about sharpening particular areas

of an image – as a portrait photographer, for example, would be – sharpening for us is a little simpler than for some other photographers. Further sharpening of an image can be done with the Sharpening slider in Lightroom, but most images will probably not need it until printing, when Lightroom again adds a preset amount of sharpening. Bear in mind that sharpening controls cannot rescue an out-of-focus image.

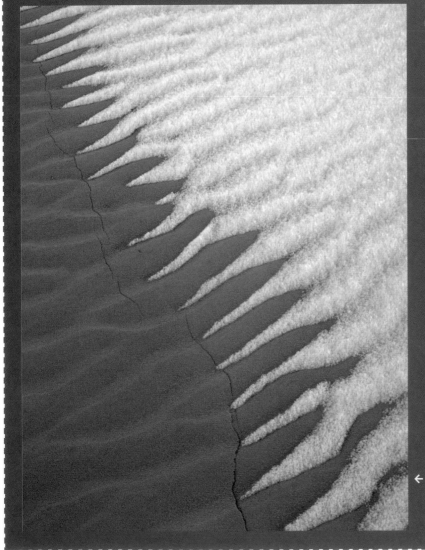

VISIBLE GRAIN

The sharpest images come from 4x5 transparencies. Here, every grain of sand and every snow particle is visible. To ensure sharpness in your 4x5 shots, always use a loupe on the ground glass to check your focus. I carry mine around my neck during intense sessions so that it is readily available.

← **Coral pink sand dunes and snow, Utah**
Toyo Field 45AII camera // Rodenstock 210mm lens // Fuji Velvia 50 film // 4 seconds at f45

MAKING STITCHED PANORAMAS

I have always been keen on the panoramic image format and I have had a great deal of fun making panoramic photographs by exporting images from Lightroom into Photoshop CS3's Photomerge feature. It's very easy to use, and the results are wonderful. The procedure is simple, as you will see in the box on the right.

PANORAMAS USING PHOTOMERGE

1. In the field, create the pieces of a panorama by shooting the subject in sections. To keep everything straight, I use the level on my tripod and shoot as many images as I need to create the panorama I have in mind. I try to do this as quickly as I can to avoid changes in the subject that will be hard for the stitching program to deal with. Using a level on your tripod or camera is always a good idea for this technique.

2. Select the best panorama sections in Lightroom, making sure that exposure and colour match well. Open Photoshop and export the images to that program.

3. In Photoshop, go to File, scroll down to Automate and choose the Photomerge function. Click Browse and choose Auto to bring in the panorama sections. Click OK and let the magic begin.

4. In a minute or two, Photoshop will have created a panoramic image. I've made about 20 now, and they all have been excellent – clouds that were moving blend seamlessly into one another, slightly different exposures even out to a homogenous whole – and I have effortlessly created panoramas that in some cases extend well over 240 degrees.

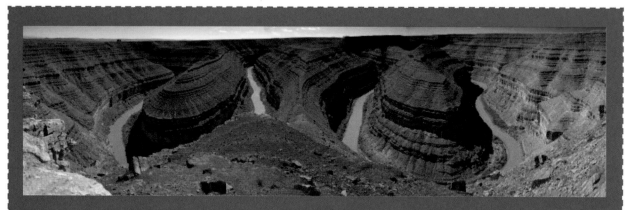

PANORAMIC CURVES

For years I had tried with various different panoramic cameras and wide-angle lenses to show all the sinuous curves of the Goosenecks of the San Juan River in one image, with no luck. With the Photomerge feature in Photoshop CS3 I was finally able to accomplish what I wanted.

↑ San Juan River Goosenecks, Goosenecks State Park, Utah
Fuji FinePix S5Pro DSLR camera // Nikkor 18-200 lens // 1/4 second at f28

USING HDR IN PHOTOSHOP

HDR stands for High Dynamic Range, and refers to images with such a huge range of light values that even Lightroom's magic and GND filters can't help. Also, HDR problems can occur with images where areas of the scene are lit in such a way that a GND is not effective in correcting the problem. Photoshop's HDR function has the power to select the best exposures from a number of bracketed images (try four or five from very dark to very light) and merge them into one image.

Though I still prefer to use GNDs in the field for this sort of thing, HDR may be able to solve some previously insoluble exposure problems.

After downloading and accessing your images in Lightroom, export them to Photoshop and proceed as you would with the Photomerge feature. You will see the HDR control on the same screen, called Merge to HDR. Use Browse to select your images.

For HDR enthusiasts I also recommend a dedicated HDR program called Photomatix, which offers more advanced features than the Photoshop version.

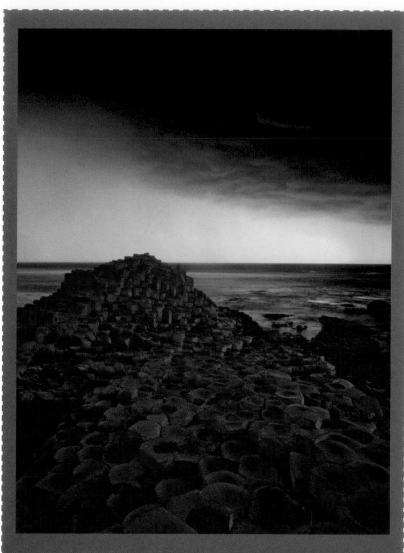

TURBULENT SKIES

Never shy away from bad weather; embrace it. Countless possibilities abound when skies become turbulent. If it's not raining too hard, a motel shower cap can protect your lens, and some of the newer high-end DSLRs seem practically impervious to everything but full immersion in water. Drops of water on the lens can often be fixed in Lightroom or Photoshop.

↑ **Giant's Causeway, Northern Ireland**
Toyo Field 45All camera // Nikkor 75mm lens // Fuji Velvia 50 film // 8 seconds at f45

DIGITAL BLACK AND WHITE

I have to admit that I am a colour photographer, and though I love black and white, I have very little experience with the craft. Now, however, with Lightroom or Photoshop, I can create passable black-and-white renditions for a client or other purpose.

Colour

Black and white

Black and white in Lightroom

In Lightroom's Develop module, simply click on the Grayscale button and the image will turn to a black-and-white rendition. To return to the colour version, press Color. You can look at every image this way and decide which ones might make the best black and whites. Also, if you wish to keep or work on a copy, you can make a virtual clone in the Photo menu. Making really wonderful black-and-white images with rich blacks and wide tonal scales is possible in Lightroom, but it is a multi-step process and beyond the scope of this book. A good Lightroom manual should be able to guide you through the process.

Greyscale conversion

A simple greyscale conversion in Lightroom produced the colour and black-and-white versions of the image you see to the left.

↖ **Proposed Canyonlands Basin Wilderness, Utah**
Fuji FinePix S5Pro DSLR camera // Nikkor 18-200 lens at 27mm // f22

FILING AND WORKFLOW

After all colour corrections have been made and all editing is finished on a particular shoot, I backtrack to the Library module to file my digital images in Lightroom and also prepare them to go into my iPhoto digital stock library. (As the library has grown, I have come to the conclusion that iPhoto is not the best program for my purposes, although for non-professionals with smaller libraries it should work fine. At the time of writing I am looking at several alternatives.)

First of all I make prints of all the 'keepers' and assign them numbers from my analogue catalogue. These numbers will also be assigned to the images in Lightroom. At the same time, I use the Folders section of the Lightroom Library to hold the images filed by geographic location, just as my 4x5 images are in my physical folders and cabinets. Finally, metadata is added to the images and they are added to the digital stock library. The images then appear online in my two online digital stock libraries – one for browsing for the general public, and the other for use by photo buyers and potential clients.

Taking into account both the images we scan from transparencies and the digital images coming from Lightroom, my staff and I add about 500 new images a year to the library.

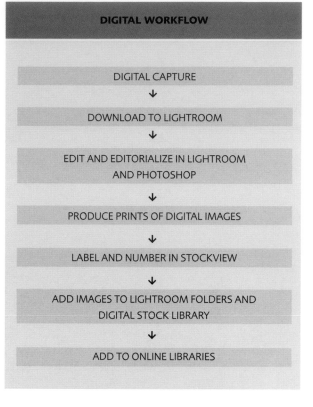

DIGITAL WORKFLOW

DIGITAL CAPTURE
↓
DOWNLOAD TO LIGHTROOM
↓
EDIT AND EDITORIALIZE IN LIGHTROOM AND PHOTOSHOP
↓
PRODUCE PRINTS OF DIGITAL IMAGES
↓
LABEL AND NUMBER IN STOCKVIEW
↓
ADD IMAGES TO LIGHTROOM FOLDERS AND DIGITAL STOCK LIBRARY
↓
ADD TO ONLINE LIBRARIES

PRO TIP

If you need to make major changes to your images – such as removing telephone poles or jet trails – then the Clone Stamp and Healing Brush tools in Photoshop are your best choice. If the problem is just sensor dust appearing in your skies, then Lightroom can help: pull up your toolbar in Develop and notice the 'male' symbol pointing at another circle. Click on this button and choose Heal. Select the photo you want to work on and the use the Spot Size slider to encircle the flaw. Click again and the dirt will magically disappear, while a circle that indicates the area sampled by the Heal control will appear. Do this as much as you need to remove the dust from your skies, and click on the symbol again to remove the circles.

PRINTING

Though most of my photography business has been providing pictures for publication, I have always had my hand in the printing side of the equation. I started printing myself with Ilfochrome when it first appeared in the 1970s, learned dye-transfer printing before it rode off into the sunset, and have collaborated for many years with a master Ilfochrome printer for my galleries. Most recently, I have purchased a large Canon inkjet printer to begin printing again myself. So, for me, colour printing of landscape photography has come full circle.

Making the prints you want

With digital technology and inkjet printers it's possible to make prints of any size and quality. If you're just interested in small prints for your own use, then the Print module of Lightroom may be all you need. If you'd like to make bigger prints with higher fidelity than what you see on your computer screen, and you want to use better printing paper, that's also possible. Inkjet printers have come a long way in the last few years, and many of the early problems with colour management are now much easier to resolve with colorimeters and new software, including RIP (raster image processing) technology.

Also, every part of the process just keeps getting better and better – and easier, too. Printing papers available today run the gamut from good to excellent, fine-art quality materials with staggering archival longevity. The addition of more inks to the process in the new Canon printers is also a major step forward in expanding the colour range of your prints.

Although the complete process of colour printing with inkjet papers is too large a subject for this book, let's review the basic process from the standpoint of trying to produce the best colour landscape prints possible.

← The Canon iPF8000 12-colour inkjet printer is designed with professional photographers in mind and can produce very high-quality prints up to 44in (112cm) wide.

↑ Inkjet prints made directly from Lightroom.

Printing from Lightroom

You may find that the printing facilities included in Lightroom are so good that you don't need anything else. With this software and a good inkjet printer you may be fully equipped for all but the most demanding of large fine-art prints.

You'll find it easy to put several prints on one piece of paper using various design templates, and also to add text to make great promotional flyers or other print pieces.

Lightroom colour management

Lightroom will also help you with colour management. As you move through your options before making a print, I suggest you use a larger DPI setting than the preset 240 for small prints – say 300 or 360 DPI. You might like to go with a higher DPI for larger prints, too. Many photographers also like to do a final sharpening step before printing. You can make test prints and experiment with the settings for sharpening there – you can choose from High, Medium and Low. I prefer Medium or High for my jobs.

It's easy to let Lightroom perform your colour management automatically. First, though, Lightroom needs the colour profile for the particular paper and printer you use. This profile can be found and downloaded from the manufacturer's website, and kept in Lightroom for future use. More profiles can be added if you use more papers or other printers.

Now you're ready to print, easily and in most cases with amazingly good results.

PAPERS AND PRINTERS

Choosing paper

It's important to choose a paper you like and that will display your images at their best. The selection is so large that it's a little overwhelming, so tests of several papers (you can obtain free samples from many manufacturers) might be the best way to start. I tested a large number of papers and, frankly, often had a hard time telling the expensive ones from the cheaper lines. In the end, we chose a glossy Ilford paper that imitates Ilfochrome in its look, something I was keen to achieve. The paper also had a high GSM (grams per square metre) value, which is also desirable. We have found all inkjet papers we tested to be very fragile; they are easily scratched and easily dented.

Paper longevity is another important factor in paper selection. Several websites claim to give accurate information about the archival nature of various papers. Almost all quality inkjet papers have a high rating.

I recommend the thickest paper that fits your needs to help a little with the denting problem. Even then you will need to use gloves and handle the prints with the utmost care – grabbing them on opposite corners can be helpful in avoiding folds and dents. To avoid scratches, we place a special photographic acid-free tissue paper between prints to protect them, making sure they are not touched by other prints.

Choosing a printer

Epson has led the way in printer technology since the inception of inkjet technology, but I use Canon printers because I like the idea of using the same manufacturer from camera to printer. I also think the extra inks Canon offers produce stunning prints with a huge colour gamut.

My printer makes prints 44in (112cm) on the short side, big enough for most of the jobs at my galleries. I have always liked big prints, and landscape photography is definitely a genre of photography that works well with giant prints.

Colorimeters

Colour management is easy with Lightroom, but a colorimeter is a key tool if you're making prints without it. The colorimeter uses ICC profiles provided by the paper and printer manufacturers and matches them to what you see on the computer screen. We use two Apple computers to drive our Canon printer – one is the calibrated screen that holds the files of all of our prints, with a different file for each print size we offer: 11x14, 16x20, 24x30 and 30x42. Our panoramic prints are also included.

RIPs

The second computer controls the RIP (raster image processor), which is a control center for the printer – although it's expensive, it is indispensable if you expect to do a lot of fine-art printing. RIPs do a lot of things, and once a particular image has been through the colour calibration process, the RIP can automatically control the printing of it in the future.

The RIP has another advantage if you are self-publishing a book – it can print book proofs for you right in your own office. One full set of book proofs can easily cover the cost of the RIP.

→ **Zion National Park, Utah**
Toyo Field 45AII camera // Schneider 120mm lens // Kodak VS film // 1 second at f45

This image is a typical best-selling print from my gallery. Scanned from a 4x5 transparency, the print is stunningly sharp at large sizes, and has a large palette of subtle colours.

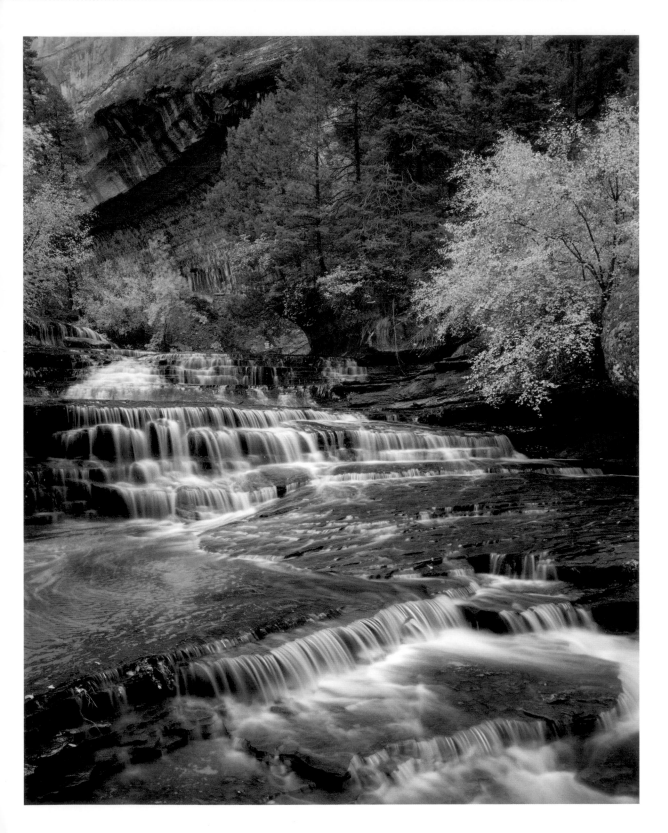

A CAREER IN PHOTOGRAPHY

I receive a lot of letters and email messages from people of all ages who are interested in pursuing a career in landscape photography. Most resemble this message:

> *I'm 15 years old, and I was looking into starting a career in photography of, like, nature, mountains, deserts and all that stuff, but I'm not sure how to get started. If you have any ideas or tips that could help me out could you please email me back. I'd love to know. Thanks for your help.*
> **A future photographer**

Although this message is from a young person, I get just as many queries from adults and retirees about pursuing landscape photography as something more than a hobby.

Getting started in photography as a profession can bring a number of hurdles, so I've thought about my formative years and the kind of advice that would have helped me back in the 1970s when I started.

→ **The Fairy Chimneys, Turkey**
Toyo Field 45All camera // Rodenstock 90mm lens // Kodak VS film // 1 second at f32

ADVICE FOR ASPIRING LANDSCAPE PHOTOGRAPHERS

1. Stay in or go back to school

Nature photography is not really a course of study at the university level, so what should a student of any age pursue? College photography is a great idea, and I took a number of photography courses at college level long after graduation from university. If you want to pursue photography as your life's work, I suggest two other areas of study that will help: computers and business. Photography is becoming a totally computerized pursuit, and I spend at least as much time on the business side of landscape photography as I do on the creative side. Marketing and disseminating your imagery requires many skills that business classes can hone and perfect.

2. Join a professional group

There are numerous groups worldwide dedicated to nature and landscape photography. If, like me, you're based in the United States, the North American Nature Photography Association has a great track record for nurturing and supporting aspiring nature photographers. Although the group is a little more slanted toward wildlife photographers than landscape, they offer scholarships, portfolio reviews, and various other benefits. The annual convention is a great place to meet and network with photographers from around the world. Also at the convention, aspiring photographers meet and talk with professionals and attend seminars that feature a wide variety of subjects within the nature photography world. Contact NANPA at www.nanpa.org for more information.

3. Find a mentor

This recommendation will be the most difficult. There just aren't enough journeyman landscape photographers out there to train the ranks of those who will replace us. People constantly say to me, 'Let me tag along and carry your tripod,' but I want to make sure my time is spent personally training people whose level of commitment borders on the fanatical.

4. Shoot, shoot, shoot

Photography is like golf or the guitar. Practice is the most important element in achieving photographic excellence. Framing the world in a rectangular box, and shrinking three dimensions into two, is a skill perfected by years of trial and error. I attribute most of my success in photography to the 90 percent perspiration, 10 percent inspiration rule. I often say, and it's not false modesty, that I don't have any talents the average person doesn't have. My best images stand atop a pile of many bad ones that have taught me what works and what doesn't. Like my musical hero, Brian Wilson, says, 'I'm not a genius; I'm just a hardworking guy.'

5. Have fun

Though I have made landscape photography sound a little like drudgery in the preceding paragraphs, nothing could be more enjoyable than getting out into nature and trying your best to capture a smidgen of the earth's incredible beauty. The joy of photographing the gestures of nature and landscape – from the sublime and majestic to the small and subtle – is just plain fun.

← **Doha, Qatar and reflection**
Fuji FinePix S5Pro DSLR camera // Nikon 18-200mm lens at 18mm // 1/250 second at f8 // No tripod

SELF-PUBLISHING

Most photographers dream of having their images published in book form. I know I did. Books are also a great way to get parts of your portfolio out into the public eye. With computer technology, designing, printing and publishing your own book is more of a possibility than ever before, and can also become a moneymaking proposition.

Books in small quantities

A number of companies will now provide you with a 'short run' – or small quantity – of 10 to 100 copies of your book. This is perfect if you want a book to send to clients or potential clients, but not to sell to the public. Though prices vary, companies I've looked at charge about $30 (£15) per book for printing a good-sized short-run book.

Printing to sell

Publishing your own books, cards or calendars is a great way to make money in the landscape photography business. In Colorado, for example, at least a dozen photographers are making money, some quite a lot, by self-publishing their photographs in books and calendars. I have had a great deal of success with the same formula. Obviously there is some risk, and a large initial outlay of cash. My last self-published book cost almost $40,000 (£20,000) for 5,000 copies and sells for $39.95 (£20). All work for the book except the actual printing was done in-house, including the design, scanning the images, the CMYK conversions and the essay writing and proofing. The book itself is then printed in Asia where printing costs are much lower than in the United States.

Subject matter

With self-publishing, we have found that we have the most success with books based on smaller geographical areas. For example, a book about Moab, Utah sells better than one about the entire state, while a book about the state of Utah sells better than one about the southwest or the United States as a whole.

Cost

Smaller, less costly paperback books are also easier to sell than heavier hardcover editions. We started with smaller books, waited for them to become successful, and moved to hardcover products later.

Calendar sales

Although we contribute to a large number of calendars from other publishers, printing and selling your own calendars can make money. Unfortunately, unlike a book, calendars are dated material. We like to have our calendars out on the market by June to take advantage of a full six months of selling opportunities. The calendar business is more cut-throat and competitive than the book business, but it's still possible to find your niche.

Postcards

Postcards require the least investment of all, and can be sold without time constraints. Distribution of wholesale postcards is perhaps a little harder than books and calendars, however, and it may require some salesmanship to get them out to shops where they can sell.

Distribution

Now that you've published a book, calendar or postcard series, how do you distribute the product? I know some photographers who actually travel around shooting and selling their books out of their campers as they go. For us, the key has been having our own stores in which to sell the books, and getting them out to various distributors who take a cut and market our books to bookstores regionally. The nice thing about this arrangement is that we don't have to service hundreds of accounts and bill and collect from them and fulfill their orders. Of course the distributors take a cut, but since our overhead is so low, we still make money.

↘ A selection of the author's self-published books.

ASSIGNMENTS

After you've established a reputation via stock sales, a gallery or publishing your work, you may be asked to do assignments. Assignment work for landscape photographers is hard to come by, but you may be surprised at the number that come your way once you gain a little notoriety.

I approach assignment photography the same way I would self-assigned work. I only do assignments that are outdoors and I avoid photographing products and models, since I really don't have the experience and expertise to try those genres. I do use all the tools and techniques of a normal shoot: using the best light, aspiring to get the sharpest, best-quality image and scouting the location to get the best vantage points and sun angles.

The day rate

Payment for assignment work is usually done with a day rate, plus expenses. Since I will be pulled away from my normal income-producing activities, I set the day rate quite high, but I charge less for days when I am scouting or travelling. I also set the day rate much, much higher if the client wants to buy out the images. If I can use the images myself for other purposes, I'm reluctant to give up my rights to them, and you should be also. Whatever you do, be sure to get all the arrangements with the client in writing before you do any work. I have had some assignment jobs where the client has been reluctant to comply with this request, but you must insist upon it.

TRADES

In recent years I have done several trades. In these situations I am given a free trip, usually with my wife as an assistant, with all expenses paid. I then give copies of the images to the client in return for the trip. Sometimes the monetary value of the trips, especially for two, far exceeds what my day rate would have been, and I am left with stock photography of some spectacular locations as a bonus.

↘ **Moore River National Park, Australia**
Toyo Field 45AII camera // Rodenstock 90mm lens // Fuji Velvia film // 1/4 second at f45

RUNNING A PHOTO GALLERY

A photo gallery is probably one of the best options for photographers who wish to make a living at landscape photography. Start-up costs are high, but with digital printers and digital control, beautiful prints can be made for a small amount once you're set up.

Location, location

Landscape photography galleries work well in cities, but can also be successful in small towns frequented by tourists. If you live in or near a likely spot, the best idea is find a main-street location that will be frequented by as much foot traffic as possible. Depending on the condition of the building, the only thing you may need to add is lighting – your prints need as much powerful halogen spot lighting as you can afford. Remember to offer images of the surrounding area. Most visitors will want an image of the place they are visiting as a keepsake.

The biggest problem with starting a gallery is that you may need to work there yourself to survive. This is difficult, since you will need to be in the field to get more good images to sell. The only solution to this problem is to keep working hard enough to be available to eventually hire employees to allow you the time to shoot.

Besides the prints in your store, which will be the big ticket items, it's important to have a wide range of price points – mini prints, postcards, posters and books. If you're really ambitious, you may want to do your own framing and shipping, which would have the benefit of allowing you to control the product all the way down the line.

Internet sales of prints are also a great revenue generator. But don't expect to sell prints online without a bricks-and-mortar store.

We find that all our online sales come from customers who have already been into the store and are suffering from non-buyer's remorse. People are generally reluctant to buy a print they have only seen on their computer screen, no matter how beautiful it may appear.

↘ Winter at Devil's Tower, Wyoming
Toyo Field 45All camera // Rodenstock 180mm lens // Kodak VS film // 1/2 second at f45

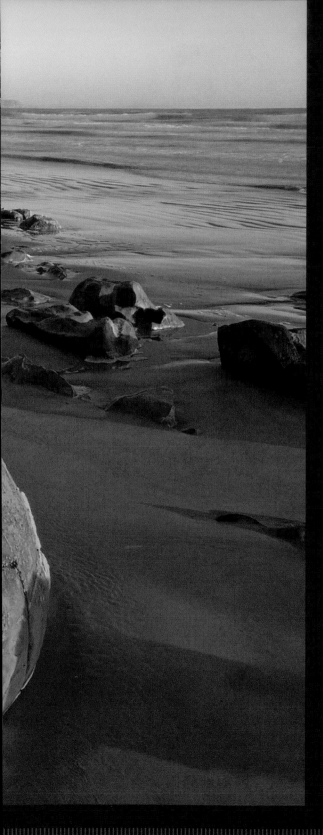

LANDSCAPE STOCK PHOTOGRAPHY

Times have changed. Ten years ago, I would have recommended shooting landscape photography stock imagery as a great way to sell your work. At the time, myself and hundreds of other photographers were benefitting from the golden age of landscape stock photography, never dreaming that it might end. 'Boutique' stock operations like mine were booming, and we had more business than we could handle, sending out film submissions by the hundreds every year to thousands of clients.

The advent of digital photography, royalty-free stock agencies and the emergence of huge, dominant stock agencies has changed all that. Fortunately for me, there are still a number of clients who have worked with me for decades and appreciate my work.

For newcomers, I believe there is still some money to be made in landscape stock, but it is probably in the emerging micro-stock market. Micro-stock agencies sell images at a greatly reduced price, hoping the photographer will make up the difference with more individual sales.

Predicting which images will be good stock sellers has never been my forte, and I feel that shooting towards a particular market is an artistic sellout. Agencies will always tell you what they want, but I've never paid attention. Everything I shoot is self-assigned. What I like most is almost never a bestseller, but as the Rick Nelson song says, 'You can't please everyone, you've got to please yourself.'

Moeraki Boulders, New Zealand
Fuji FinePix S5Pro DSLR camera // Nikkor 18-200 lens //
1.3 seconds at f29

DELIVERING DIGITAL IMAGES TO CLIENTS

There are several methods for delivering stock images to clients, either for their use or for consideration. The most sophisticated of these for us is our website. Images can be selected, downloaded and paid for directly from the site.

On the other side of the coin, the easiest way to send images to a client is via attachments to email, although most customers will not like this method, and it's difficult to send higher-resolution images.

Most commonly, we make viewing platforms for our clients, giving them a special website address for them to go to with images specially edited for them at a lower resolution than normal.

Finally, we also upload images to our own secure FTP site. Clients who want to see even higher-resolution images, or who are getting the actual file they will use, would utilize this site. They are given codes to download the images for usage. If you're less concerned with security, many clients have their own FTP sites. In this process the client sends a link from their FTP site to us and we upload to that site, from which the client can obtain the image.

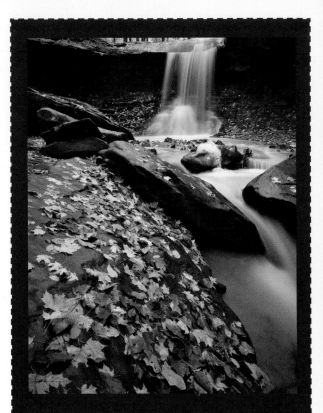

FALLING LEAVES

Being at the right place at the right time is always a combination of luck and work. I waited for a week for the combination of rain-swollen water and fallen leaves in this image. The overcast day eliminated any lighting concerns. A large maple with red leaves hung right above the falls, dropping the bright leaves in the rain.

↑ Blue Hen Falls, Ohio
Toyo Field 45All camera // Rodenstock 90mm lens // Kodak VS film // 2 seconds at f45

SELLING PRINTS AT ART FAIRS

A number of photographers make a good living or a substantial addition to their incomes by selling prints at art fairs. These fairs usually occur during the summer months and may require a lot of travelling. Prints sold at these venues are usually generic in nature, and have to be very affordable – since customers will usually be taking the prints away at the time, framing is not usually an option; prints are usually no larger than 16x20, and mostly in the 8x10 to 11x14 range. As a result, the idea at these art fairs is to sell larger quantities of cheaper prints. Inkjet prints, which offer high quality at a small investment, are probably the best option.

Most of the art fairs require the artist to be present at the event. Spending so much time dealing directly with the public can be an amazing education about what people want to see and buy, and what they don't. This information could spill over into your stock business, and help your photography become a commercial success.

↓ **Crater Lake, Oregon**
Toyo Field 45AII camera // Schneider 90mm lens //
Kodak Ektachrome film // 1/2 second at f32

PRO TIP

Shooting into the sun is a difficult exposure problem. First, especially in the mountains and deserts with low humidity and clean air, it can cause flare. My trick is to block at least half of the sun's orb with the landscape, which is usually enough to avoid the problem – but it also means you can shoot only one or two shots at the critical time, so bracketing is not an option. DSLR shooters can quickly check their histograms, but the best option I've found is to meter the skies away from the sun (avoiding bright clouds) and use that as a starting point. 4x5 shooters may want to use Kodak VS film, which has a wider exposure range and less contrast.

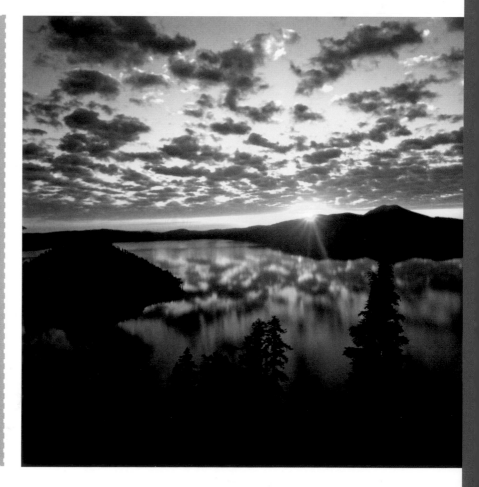

DIVERSIFY YOUR BUSINESS

Chances are, if you want to make a living at landscape photography, you might want to try many or all of the income-producing ideas I've presented, and some others I haven't. Here are a few more ideas.

Teach workshops

If you're gregarious and good with people, have a teaching background or just enjoy sharing your photography knowledge, teaching workshops might work for you. This has definitely been a growth industry in photography in recent years.

Guide photographers

A related activity, guiding photographers, has also seen a rise in popularity recently. Although a teaching component may be informally offered, the main activity here is to take clients to sites when the time is right so that they can get good images themselves. If you have knowledge of the photography hotspots in a certain area and when the light is best, you might be able to build up a business as a guide.

Sell your computer skills

Most photographers can barely keep up with the advances in digital photography, and may need help with all parts of their computer activities. I'm pretty computer savvy, but we have two computer gurus who work with us on all aspects of our business. Computers have melded with cameras so pervasively that if you have an interest in cameras and computers, there's probably someone you can help.

PRO TIP

Many interesting outdoor subjects are lit artificially at night and can make great subjects if your timing is right. The key is to match the brightness of the sky with the light value of the subject. As twilight approaches, I get my shot set up and take constant meter readings with my handheld meter on the sky and the monument, castle or other attraction. When the two readings are the same, I begin shooting. Usually this is a small window, lasting only a minute or two. The image shown on the right also required waiting four days for the tide to come in with a sunset and provide me with a reflection as a foreground, rather than mud flats.

Digital slideshows

I'm asked to do digital slideshows all the time, usually for excellent pay. This activity requires purchasing a digital projector and using a laptop to run the show. I prefer the Apple application Keynote for my presentations, which projects my scanned 4x5 transparencies with fantastic fidelity. I have about ten shows on my laptop and I add new ones all the time. Though I'm not a great public speaker, having the images to talk about really makes it an easy gig.

→ **Miyajima Island, Japan**
Toyo Field 45AII camera // Rodenstock 210mm lens // Kodak VS film // 15 seconds at f32

↘

BECOMING A PRO

Tax advantages

Although tax laws are different around the world, you may find that turning a landscape photography hobby into a more serious commitment and making strong attempts to sell your work can have tax advantages.

Your business

The first steps towards being a professional should involve following the steps that any new business would take: get a business license, buy a letterhead and open the relevant bank accounts.

In the United States, the determining factor in whether you can deduct your business expenses from photography (which might include camera equipment, computers and travel expenses) is contingent on proof that you've made a major effort to make money from the trade. If this is legitimate and serious, and provable, you may be able to lose money for a few years while you establish yourself. Another key factor is how much work you've done marketing your images. If you've had few sales but made Herculean efforts to make money, and you can prove it, most likely you'll get the tax advantages. It should be noted that tax officials are likely to be tough on 'hobby' businesses, and you may be more open to an audit than you would be otherwise.

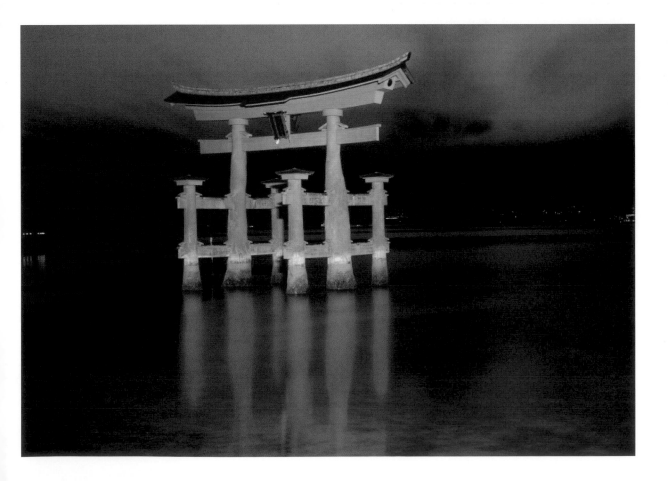

YOUR WEBSITE

One way to establish your credentials as a professional is to have a vigorous website. Anyone trying to make a living as a photographer these days needs one. Lightroom has an entire module for website creation, and you may be able to create a site on your own without help. With an online store for sales of prints and stock photography, my website has been created by professionals, although I do have a Lightroom-like section where I upload new work myself as soon as I create it. In the days of film only, I was often sending images to clients on the same day I received them from the lab, and these instant uploads are similar to that process.

My website at www.tomtill.com also features a blog. While writing this book, I found I had a lot to say about landscape photography and the issues surrounding it. My blog covers every aspect of landscape photography, and I think you will find it a good resource as you explore the joys of landscape imaging.

BUSINESS AFFAIRS

Just as your commitment to photography will dictate your artistic success, your commitment to your business will be critical to its success, whichever landscape photography path you may choose. I have met, talked on the phone and corresponded with hundreds of photographers over the years who wanted to make landscape photography their living, but only one or two have actually accomplished the dream.

An expensive endeavour

Why so few? For one thing, landscape photography is expensive. Though digital photography may have brought some costs down, other items have taken their place, and the biggest cost of all, transport, continues to rise at an alarming rate. Also, landscape photography is time-consuming. To get the best images, professional landscape photographers spend months in the field. Unless you're independently wealthy, there's no way to finance all this without some money coming in. My trick was to be a high-school teacher with generous vacations, and I also live in a beautiful location where I can shoot scenics every day of the year without travelling too far.

Dealing with rejection

None of us at Tom Till Photography, Inc. has any formal business training, and I don't see it as a prerequisite for success in the photography business. A thick skin might be a better attribute, because you will suffer rejections throughout your career. I remember thinking in 1983 that nobody would ever buy my images, but I didn't give up, and each setback steeled my resolve. I think a lot of people quit, or never start, because their egos are too fragile to handle the criticism.

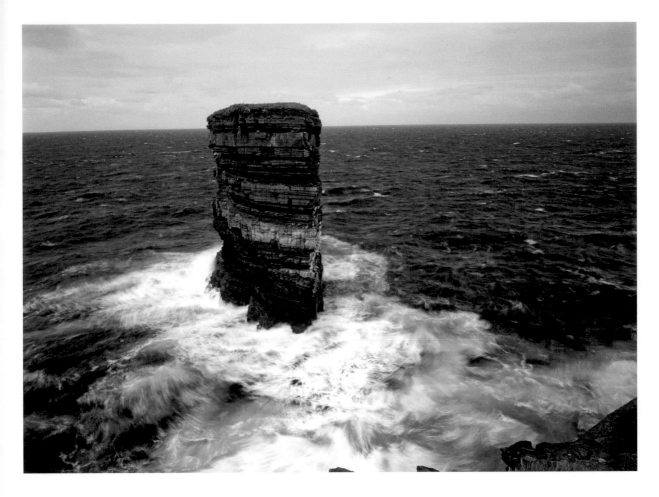

Business philosophy

Our landscape photography business (I use the term 'our' in this book to include my wife, who has been a indispensable part of the enterprise; and my employees, who have been loyal, hardworking and competent) is built upon the idea of friendship with clients and customers; a 'customer is always right' philosophy; an obsession with quality over money-making; an attempt to keep up with modern technology while holding on to old-fashioned values; and quick response to requests from everyone we work with. Also, I never turn down a job, and I'm thankful every day to have my job — it's one lots of people seem to want.

↑ **Sea Stack in Morning Light, Republic of Ireland**
Toyo Field 45AII camera //Rodenstock 90mm lens // Fuji Velvia 50 film // 2 seconds at f45

PRO TIP

One thing editors look for while browsing websites is the addition of new material. Try to keep the images coming as fast and furiously as you can. For one thing, it will mean you are out shooting on a very regular basis, which is the key to becoming a better photographer, and you'll have lots of content to keep your website fresh. My site gets a complete overhaul about every five years – but with Lightroom, you can change the look of parts of your site on a far more regular basis.

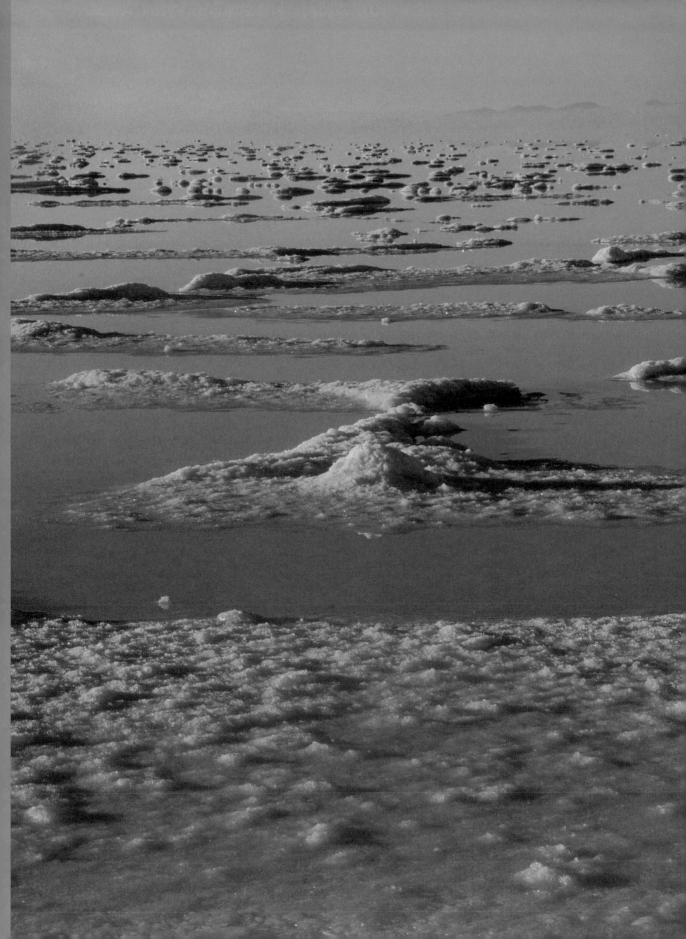

09

THE ART OF LANDSCAPE PHOTOGRAPHY

Salt forms on Great Salt Lake, Utah
Fuji FinePix S5Pro DSLR camera // Nikon 18–200mm lens at 62mm //
1 second at f32

I have always tried to spend part of every day in the field shooting images that I think are 'artistic,' meaning those that seem to transcend the usual postcard view – although shooting a great postcard view is also an art in itself. This image seems artistic to me for three reasons: first, because it's unusual, an important attribute of art; second, it's somewhat abstract, another common thread; and finally, it's evocative of an idea: the lake water looks like sky, highlighting the sometimes tenuous nature of our perceptions of natural features.

STUDYING THE MASTERS

Looking at the imagery of master photographers can be a great armchair exercise for aspiring amateurs, and even other professionals. I often find that photographers are more interested in their own work than other people's, and I think this is a shame. I remember when I was first becoming serious about landscape photography that I would spend every available moment looking at the work of published photographers. I did so not to copy their work, but to see how they were handling light, composition, colour, lens selection, image creation and all the other important details of landscape photography.

I also think it's important that photographers realize that our art and craft has a history, and that without the contributions of some of the great landscape photographers of the past, we would not have the pantheon of great landscape artists worldwide that we do today.

Though I have a very large collection of landscape photography books, I learned the most from three photographers: Eliot Porter, David Muench and Phillip Hyde. Porter and Hyde have passed on, unfortunately, while Muench continues to produce new work into his seventies. All are mainly 4x5 shooters, and were at the height of their popularity during my formative years as a landscape photographer.

From Porter I learned about shooting intimate, close-up subjects and the desire to photograph in locations worldwide. Hyde taught me that shooting during the middle of the day can be a rewarding experience, and that using your images to champion the natural world is a prime responsibility for a nature photographer. David Muench's work ethic is second to none, and he also pioneered the idea that all landscape

work did not have to occur during sunny weather, and that bad weather and landscapes can be a fantastic combination.

Intimate Landscapes

Some of the most artistic and earliest colour images of the landscape came from the camera of Eliot Porter. If you are not familiar with his work, I suggest checking eBay or Amazon, where copies of some of his magnificent books may be for sale (see page 172, Further Reading).

Eliot Porter

Porter was given some of the first colour film by Kodak, and took some of the world's first colour images of wild birds. He quickly changed his focus to landscape and nature imagery, and did something revolutionary. Instead of the big scenic popularized for decades by black-and-white photographers, Porter made what he called 'Intimate Landscapes'. Not macro imagery, but photos that depicted a smaller, less grandiose take on the scene. Using a 4x5 and long lenses, Porter rarely took a wide-angle photograph, and seldom had sky in the shot. His artistry came from the use of rich colours, abstract subjects and brilliant compositions.

ROOT DETAILS

This image of tree roots in China is typical of the intimate landscape genre. Pattern is the key compositional element, and a lot of care was taken in trying to create a pleasing overall composition. Notice that simplicity is also a keynote.

→ **Fig tree roots along the Li River, People's Republic of China**
Toyo Field 45All camera // Schneider 120mm lens // Fuji Velvia 50 film // 1/2 second at f45

TELLING STORIES

Light and colour alone can make a great image, but there are many more elements we can hunt down in the great outdoors. Whenever possible, I look for stories to tell. Rod Stewart said it ungrammatically – *Every Picture Tells a Story, Don't It* – and every great picture does.

The themes of the stories we can tell with outdoor photography are usually simple and archetypal: the change of the seasons, the moods of the weather, the mystery of birth and death,

the love of beauty and the unparalleled splendour of the natural world. A photograph I made near Hanksville, Utah, of spring flowers pushing up through the blue-cracked mud, is a bestseller at my galleries because it tells a small story about the struggle of life and the possibility of renewal. Women in particular seem to love the image and respond to it.

The psychology of visual stories is a rich and fascinating subject, and having a photo gallery in which to experiment with themes and motifs is a great way for me to try out these ideas to see how the public will respond. You can do the same same thing with slideshows in Lightroom.

BE SPONTANEOUS

This image, mentioned above, is also instructive because I almost didn't take it. After shooting huge fields of flowers, I looked down at my feet and composed the image as an afterthought. One of the reasons I've fallen in love with digital 35mm photography is the ease with which this kind of spontaneity can be indulged. I urge you to experiment boldly in the field, and not to edit yourself too closely. Take risks and you will be rewarded with some of your best images.

→ **Cracked earth and wild flowers, Utah**
Toyo Field 45All camera // Rodenstock 210mm lens // Fuji Velvia 50 film // 2 seconds at f45

SOLSTICE MOOD

Sometimes a new view of a much-photographed subject can be very difficult. My idea on this famous scene was to visit at moonrise during the winter solstice, the only time the moon is far enough north to be included in the scene. I didn't get the rich reds most people try for here, but the pastels and the moon provide a different mood.

← **Monument Valley, Utah**
Toyo Field 45All camera // Roden-stock 210mm lens // Fuji Velvia 50 film // 6 seconds at f45

YOUR PERSONAL VISION

One of my pet peeves about landscape photographers is that they tend to congregate at certain scenes that have been shot a million times before. I don't even think they're hoping for something new; they want to bag the same famous scene and have an image that looks like all the others they've seen. What a waste of time! Are people so uninspired, lazy or unimaginative that they have to copy, copy, copy? Wouldn't finding and shooting something new provide everyone with more satisfaction?

A trip to Mesa Arch in Canyonlands National Park in Utah or the Snake River in Grand Teton National Park, Wyoming on any morning of the year will convince you that there's a lot of landscape picture cloning going on.

Breaking out

Every photographer goes through an imitation stage, trying to emulate the work of the masters they admire. I think this is normal, but after a while, aspiring landscape photographers must transcend this phase and try to become more confident in pursuing their own vision.

I can attest, from teaching workshops and looking at the work of a lot of people at various stages of photographic proficiency, that everyone has a unique personal vision. I also believe that each person's individual take on landscape photography has value and deserves a chance to flourish – a chance that will be diminished by showing up at the standard locations and served by striking out on a new path.

LOVING YOUR SUBJECT

Landscape photography is not all fun and games. I think people have a very romantic image of the landscape photographer which is partly true, but glosses over the trouble you can get into: broken bones, stuck vehicles, broken down vehicles, voracious insects, extreme heat and cold, blizzards and sandstorms, equipment failure, equipment theft, personal property theft, dishonest clients and partners, rejection of your work by clients, sunburn, and bad exposures are just a few of the troubles that may come your way.

To keep an even strain throughout these trials, my love of the subject has kept me going. If this burning love is not a part of your psyche, then I suggest that you will not be a success at landscape photography. Besides keeping you going when all seems lost, this love will shine through in all of your image making. In the work of the best landscape photographers, this hard-to-define quality can be seen as they dance with light and the landscape.

↘ **Kokerboom Forest, Namibia**
Toyo Field 45AII camera // 360mm lens // Fuji Velvia 50 film // 10 seconds at f45

I always keep track of the moon's phases and location in the sky. For full moon, I prefer to shoot on the day before true full moon, when there is usually still some residual sunlight on the subject. To predict where the moon is setting, I use 'pointers' – the shadows of trees or other straight objects, or even my tripod. The pointers will point just to the right of the rising moon on the night before it's full.

↑ **Riegersburg Castle, Austria**
Toyo Field 45AII camera // Rodenstock 210mm lens // Kodak VS film //
1 second at f32 // 3-stop GND filter

DRAMATIC SUNLIGHT

On a long summer day, I waited about 10 hours for the sun to be in the best place for this evening shot. The ability to predict the sun's movements is important when arriving at a scene hours before you want to shoot. I used a compass, which told me the castle faced north-west – perfect for a summer sunset. The rest is all patience, and perhaps a good book. I was also lucky to get a dark chiaroscuro cloud to add more drama; perhaps a reward for my patience. I liked the scene so much that if the sunset had not co-operated I would have returned on another day to try again.

TAKING A WORKSHOP

When I first started my career in landscape photography, photography workshops were a rarity. I desperately wanted, and needed, instruction on how to operate a 4x5 camera, but sadly no such help was available. Today, workshops of all types are available around the world, and I've taught many myself.

To be frank, some photographers are good at shooting, while some are good at teaching, so taking a workshop from your photographic hero might be fun, but it may not be the most productive move for learning about photography.

Digital learning curve

The learning curve a lot of photographers are having trouble with these days is switching to digital photography. Several digital experts, such as George Lepp in California, offer intensive training in the digital realm from shooting right through to printing, so those who want digital instruction should have no problem finding a good source for this type of training.

Sometimes photographers come to workshops expecting to have a life-changing experience, while at the same time not really being prepared to learn. Perhaps intimidated by the teacher, they are often passive and expect the learning to occur without their involvement. You'll get as much out of a workshop as you put in – be assertive, ask questions, corner the instructor about special concerns and get the information.

1.0

THE LIFE OF A LANDSCAPE PHOTOGRAPHER

James Bond Island, Thailand
Toyo Field 45AII camera // Nikkor 360mm lens // Fuji Velvia 50 film //
1 second at f45 // Polarizing filter

I assume, if you've come this far, that landscape photography is something that interests and excites you. Welcome to the world of early-morning wake-up calls, being immersed in beauty that will inspire you throughout your life and the joy of artistically communicating the beauty of the land and the wonderful feelings of accomplishment that brings. I remember many years ago being proud that my job didn't hurt anyone, and might actually be helping the earth. This chapter delves a little deeper into what being a serious landscape photographer entails, on a personal level.

It's amazing where you can gain inspiration for your next photographic trips. As a movie and TV fan, I always pay attention to locations like this island, originally known as Ko Tapu, which featured in the film *The Man with the Golden Gun*. I often watch the TV show *Survivor*, and was moved to visit the Marquesas Islands just by the scenery I saw on the show.

THE LANDSCAPE PHOTOGRAPHY LIFESTYLE

Although staying fit is a good idea for a lot of reasons, being a professional landscape photographer means doing a lot of walking and carrying heavy gear. To do this on a regular basis, you must be physically fit. I know no active nature photographers who smoke, drink heavily or are badly overweight. Since getting out of bed early for sunrise shooting is a must, people who like to stay up late socializing or partying will not have much luck in this field of endeavour. Also, since so much travelling is involved, it's important to try as much as possible to eat well, avoiding burgers and gravitating toward the salad bars when partaking of road food.

Hiking

I told someone once that my real job is hiking, because getting out into the places I want to shoot requires so much walking. My personal exercise regime includes walking four miles daily and lifting weights, with the goal of maintaining my level of fitness.

Staying in the field

It makes sense to have the skills required to spend the night in the field near the subjects you hope to shoot, and in most cases this means camping. I've spent literally years in a 'pop-up' camper on a four-wheel-drive vehicle and have found this method puts me right where the action is. A tent will do just as well, but it's less a place where you can actually live for weeks on end, something you may need to do.

Sometimes, getting great landscape photos takes copious amounts of time in the field. While boredom is sometimes a problem, especially after endless rainy days, spending a long time in one ecosystem can lead to better photos. Also, I often find that I encounter the best shot just as the light leaves, and I have to return again the next day, or the next week to get it right.

Seeing the world

Serious landscape photographers begin to see the world in a new way. We take time to notice beauty that others pass by, and that beauty leaves its mark in a positive way. The quality of sunlight, clouds and their generation and movement, storms lowering and lifting on a mountain face; all are conditions we observe, note and embrace.

Tuned in to nature

In our computerized, fast-paced, stressed-out world, nature photographers, weather forecasters and farmers may be the only ones left who live their lives the way our forebears did for millennia – attuned to the natural rhythms of sunrise and sunset, seasonal changes, the moon's phases and the vagaries of the weather. The joy of this outdoor lifestyle gives us a unique perspective on the 'important' world of stock-market fluctuations, celebrity meltdowns and sports travails.

Lifelong learning through photography

I noticed long ago that photographing any subject piqued my interest in it, whether it was a lowly mushroom in Arkansas or a great cathedral in Europe. My first trips working in American Civil War battlefields and their landscapes, for example, have inspired a lifelong interest in the subject. I photograph too many places and things to reach expert status on any of them, but photography has led me through a vastly enhanced adult-learning odyssey. Other photographers I have spoken with note the

same positive experience, and I'm convinced
that anyone who takes landscape photography
seriously can expect to be motivated to learn
more about the natural world and the landscapes
they commit to film or file.

SPECTACULAR DISPLAY

↑ **Stromboli Volcano, Italy**
Pentax 6x7 camera // 300mm lens //
Fuji 400F film // 7 minutes at f5.6

*A lifelong interest in volcanoes has led me to shoot several examples across
the globe. I try to photograph volcanoes mostly at twilight, or at night, when
the displays are more spectacular. There is always some danger involved in this
pursuit, and I used a long lens to keep far away from the active fountains and
lava bombs of this volcano in Italy.*

A DAY IN THE FIELD

This diary is an approximation of an 'average' day in the field for me, though in reality every day is different. Let's say it's August in Arizona, and I'm following a plan determined by the weather forecasts I've seen for the day. I'm hoping that any good images taken on the trip may end up in Arizona Highways Magazine, or a new book about Western North America I'm shooting.

5:00am *The alarm on my wristwatch wakes me in my camper while it's still dark. I don't usually like getting up so early, but a look out of the camper window shows me I have a sky full of buttermilk clouds, common in the morning during the southwest monsoon season. Also, since I'm shooting a natural arch at sunrise, if the clouds persist it bodes well for a good morning session.*

5:15am *I dress and crank down the pop-up camper and grab some cold green tea and a breakfast bar to eat as I drive to my previously scouted location. It has rained during the night and I worry about the dirt access road as I bring the Toyota truck to life and leave the campground. I went to bed at 11:00pm after shooting a nice sunset shot, grabbing some fast food for dinner and driving to the campground.*

6:00am *I arrive at the site – the road was fine – and hike half a mile to the arch. I'm carrying my 4x5 gear and my Canon DSLR with a wide-angle zoom and a fisheye lens. I'm hoping to shoot with both cameras and get as many of the buttermilk clouds in the scene as possible. I like to be all set up before the last star has disappeared, and I work quickly to make the deadline.*

6:45am *I begin shooting as light hits the clouds first, using a 4-stop GND to block the sky. I shoot about 15 sheets of 4x5 film and quickly take two images with the DSLR, checking the histogram for exposure.*

7:00am *My scouting has shown me that at other times of the year the surrounding ridges will block the sunlight on the arch for at least a half an hour, long enough for me to miss the magic-hour light. The arch is quite red, and I want red light to make it glow. As the sun hits the arch I continue shooting, exposing another 30 sheets of 4x5 with bracketed exposures and a few digital exposures with my Canon.*

8:00am *With the light growing ever harsher, I pack up to leave, and begin to think about the rest of my day. The first thing on the agenda is to find a large cottonwood tree to grab a 45-minute nap. These naps allow me to keep up with burning the candle on both ends during these long summer days.*

9:30am *Next on my list is scouting a nearby location that I have wanted to shoot for some time: twin pinnacles of red sandstone. The formations are right along the road (called roadkill by professional photographers) and about 30 miles away.*

10:00am *I arrive at the pinnacles to find an unexpected miracle. The recent rains have flooded the area, a very uncommon sight. I see that at sunrise the next morning they should be reflected beautifully in the inch-deep waters – assuming the fierce summer sun doesn't dry up the area completely.*

10:30am *After sizing up the area, I am pleased to have a sunrise shot already planned for the next day, and*

Toyo Field 45AII camera // 120mm lens // Fuji Velvia 50 film // 1 second at f45 // 3-stop GND filter

head off to find something for sunset. Since I need to be near the Dancing Rock pinnacles, I rent a motel for the night since no campgrounds are nearby.

12:00 noon I have lunch and plan to visit a maze of canyons I've scouted on Google Earth. Little known and seldom visited, the area has a few dirt roads that approach the rim. The drive will take me about two hours, and I will have to return after dark.

3:00pm While driving to my sunset location, my fuel gauge suddenly reads empty. I am miles from the nearest petrol station and I panic; I had thought my tank was almost full. If I run out, I will almost certainly never get back to my great sunrise shot by morning. I stop to check the vehicle to see if I have a petrol leak, and find

nothing. I decide to keep driving to the nearest petrol station, about 40 miles away.

4:00pm My petrol gauge has corrected itself and is now reading a nearly full tank. This malfunction never happens again, but for a while I was very worried. I continue with my plan to visit the nearby canyons.

5:00pm I arrive at the rims of the the Maze of Canyons (as I call it) as a thunderstorm begins to approach from the west. Lightning sparks in the sky and grows so intense I dare not leave my vehicle.

6:00pm After a short but spectacular thunderstorm, the sky begins to clear in the west, signalling the chance for a rainbow. I leave the truck and find a suitable

↗ Rainbow at Maze of Canyons, Arizona
Toyo Field 45All camera // Nikkor 360mm lens // Fuji Velvia 50 film //
1/2 second at f32

vantage point. Like the full moon, a rainbow's centre
will appear directly opposite the sun.

6:30pm *After the rainbow disappears, I continue to
shoot at the canyons, with my attention drawn to a
large pinnacle that stands alone along the canyon's
edge. I shoot the pinnacle as the sun peeks in and out
of clouds. One reason I've chosen this pinnacle is that it
is in a position to pick up light almost until sunset and is
not eclipsed by the canyon walls.*

7:30pm *As the sun finally sets, I walk the mile back to
my vehicle, excited by my day and the prospects for the
morning. I have shot about 75 sheets of 4x5 film and
several dozen digital images.*

8:00pm *I leave the Maze of Canyons vowing to explore
the beautiful and forgotten area further at another time
and begin the two-hour drive back to my motel.*

PRO TIP
||

*Another scouted sunrise shot, this view of these
amazing sea stacks required a long pre-dawn hike,
beginning at 4:00am. Also amazing was the fact that
the dawn was clear. I haven't seen a shot like this in
any Scotland book. It's an example of a great subject
that other photographers have ignored – a common
occurrence. These places are out there just waiting for
someone to click the shutter at the right time.*

↑ Stacks of Duncansby, North Sea, Scotland
Toyo Field 45All camera // Nikkor 360mm lens //
Fuji Velvia 50 film // 1 second at f32

11:00pm *I get ready for bed and make sure my
equipment is ready to go for the morning. This time I
will get a 4:30am wakeup call. The next morning I will
find my scouted shot in almost perfect condition: no
clouds, but with no wind I get a perfect reflection and
also find an interesting shot with rolled up mud patterns
that I shoot as a vertical. Shot as an afterthought, it has
sold almost as well as the reflection image.*

BEST BEHAVIOUR

In the American West, at least eight major photographic sites have been destroyed in the past few years. In some cases, the formations may have been victims of natural forces, but some, and perhaps all, of these amazing places have been destroyed by either human error or negligence. The sad, unavoidable conclusion is that photographers were involved in this destruction.

These events give all landscape photographers a bad name, and serve to force land managers to impose further restrictions on access to beautiful landscapes. As a result, I propose a code of ethics, as shown below.

PHOTOGRAPHER'S CODE OF ETHICS

» Use common sense and good judgement at all times where you photograph. Be especially conscious of your behaviour around other visitors if you're shooting in a national park or other area open to the public.

» Be careful of your demeanour and behaviour around scenic icons. Exhibit kindness and consideration to the public and to fellow photographers in these sometimes crowded places. They have as much right to be there as you do.

» Remember that no matter how great a photographer you think you might be, the natural word and its integrity is more important than your pieces of silver-covered plastic or your electronic facsimiles of the beauty of nature.

» Follow all the rules, all the time. As rules become more restrictive and parks and other scenic wonders become more crowded, this directive will become more difficult to follow, but it will also become more important.

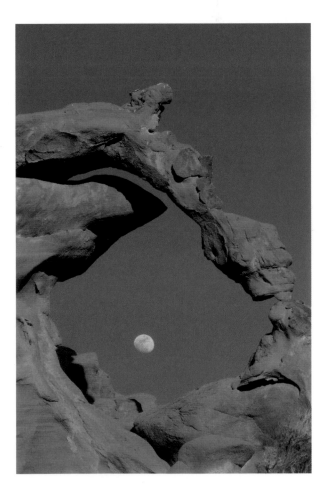

→ Arch and rising moon, Nevada
Canon EOS-1DS Mark III camera //
100–400 USM zoom lens at 180mm //
1/6 second at f36

PRESERVING THE LANDSCAPE

All landscape photographers want to work to preserve the subjects they're shooting. It goes with the territory. As a landscape photographer you can do a great deal to protect landscapes near and far. Every community in the developed world has at least one group fighting locally to save lands from development and destruction. The writer John Nichols has stated that metaphorically, every nature photograph carries with it the bulldozer, just outside the frame and waiting to come in and raise havoc.

The history of landscape photographers as environmental advocates is a long one, beginning with photos that were instrumental in creating the first National Parks in America in the nineteenth century, and continuing with attempts to stop dams on wild American rivers in the 1950s and the present-day books about global warming.

I strongly urge you to make your images available to local conservation groups – it will help the environment and your career. If your images are successful, it can be more satisfying than selling a stock image for a fortune.

I testified before the US Congress a few years ago and brought my images of a newly designated Utah park that was being fought by numerous development interests. We prevailed, and the park has remained undeveloped for over a decade. I also named the site in the shot below 'Zebra Canyon' during my many trips to photograph it. The name stuck, as have several names I've given to features I've shot over the years.

← **Zebra Canyon, Utah**

Toyo Field 45AII camera // Schneider 58mm lens // Fuji Velvia 50 film // 8 seconds at f45

↘

AFTERWORD

Unfortunately, with technology changing so fast, some of the information in the book may already be old by the time you read it. Nevertheless, at least trying to keep abreast of the advances in photography keeps us mentally agile and young. I'm not a geek, and it's hard to be in a job that demands a great amount of knowledge of both the natural world and its rhythms and the seemingly opposite world of advancing technology.

Sometimes I'm amazed at the combination of these two polar opposites in nature and landscape photography. An actor doesn't know all about cinematography, sound and special effects, yet as photographers we're expected to know our main job well as well as all the technology that now drives our cameras, prints and livelihoods. For me, though, the thrill of capturing on film or digitally a small part of the beautiful gestures of nature is the key. Everything else is peripheral. Also being able, through my images, to do a small part in the fight to preserve natural landscapes in a world that seems bent on destroying them is always comforting.

A thing of beauty is a joy forever, and a photograph of that beauty is an important reminder to others of what we hope to leave for our children. Best of luck in your photography – and be there.

← **Hallstatt, Austria**
Toyo Field 45AII camera // Schneider 110mm lens // Kodak VS film // 1/2 second at f32

GLOSSARY

Aperture The opening in a camera lens through which light passes to expose the sensor or film. The relative size of the aperture is denoted by f-stops.

Artefact A flaw in a digital image.

Bracketing Taking a series of identical pictures, changing only the exposure, usually in half or one f-stop (+/−) differences.

Burst size The maximum number of frames that a digital camera can shoot before its buffer becomes full.

Cable release A device used to trigger the shutter of a tripod-mounted camera at a distance to avoid camera shake.

Colour temperature The colour of a light source expressed in degrees Kelvin (K).

CompactFlash A digital storage mechanism offering safe, reliable storage.

Compression The process by which digital files are reduced in size.

Contrast The range between the highlight and shadow areas of an image, or a marked difference in illumination between colours or adjacent areas.

Depth of field (DOF) The amount of an image that appears acceptably sharp. This is controlled by the aperture: the smaller the aperture, the greater the depth of field.

Digital ICE Digital Image Correction and Enhancement. A system to automatically remove defects, such as dust and scratches, from scanned images.

DPI (dots per inch) Measure of the resolution of a printer or a scanner. The more dots per inch, the higher the resolution.

DSLR (digital single lens reflex) A type of digital camera that allows the user to view the scene through the lens, using a reflex mirror. See also SLR.

Dynamic range The ability of the camera sensor or film to capture a full range of shadows and highlights.

Exposure The amount of light allowed to hit the sensor or film, controlled by aperture, shutter speed and ISO-E. Also the act of taking a photograph, as in 'making an exposure'.

Fill-in flash Flash combined with daylight in an exposure. Used with naturally backlit or harshly side-lit or top-lit subjects to prevent silhouettes forming, or to add extra light to the shadow areas of a well-lit scene.

Filter A piece of coloured or coated glass or plastic placed in front of the lens.

Fisheye lens An ultra-wide-angle lens producing images with a unique distorted appearance.

F-stop Number assigned to a particular lens aperture. Wide apertures are denoted by small numbers such as f2; and small apertures by large numbers such as f22.

Focal length The distance, usually in millimetres, from the optical centre point of a lens element to its focal point.

FTP File Transfer Protocol. A method used to transfer large digital files over the internet.

Greyscale A digital image with all the colour information discarded, leaving only shades of neutral grey.

Histogram A graph used to represent the distribution of tones in an image.

Hotshoe An accessory shoe with electrical contacts that allows synchronization between the camera and a flashgun.

Hotspot A light area with a loss of detail in the highlights. This is a common problem in flash photography.

Ilfochrome A photographic process used to reproduce slides onto photographic paper. Also known as Cibachrome.

Incident-light reading Meter reading based on the light falling on the subject.

ISO Film speed rating based on standards set by the International Organization for Standardization. The higher the ISO number, the faster the film, enabling it to produce a correct exposure with less light or a shorter exposure.

JPEG (Joint Photographic Experts Group) A digital image format that compresses the file, with consequent loss of quality.

LCD (liquid crystal display) The flat screen on a digital camera that allows the user to preview digital images.

Macro A term used to describe close focusing and the close-focusing ability of a lens.

Megapixel One million pixels equals one megapixel.

Memory card A removable storage device for digital cameras.

Noise Coloured interference on digital images caused by stray electrical signals.

Non-destructive Used in digital image editing (eg with Photoshop or Lightroom) to describe processes that leave the original image data intact.

Pixel Abbreviation of 'picture element'. Pixels are the smallest bits of information that combine to form a digital image.

Red-eye reduction A system that causes the pupils of a subject to shrink by shining a light prior to taking the flash picture.

Resolution The number of pixels used to either capture an image or display it, usually expressed in PPI (pixels per inch). The higher the resolution, the finer the detail.

RGB (red, green, blue) Computers and other digital devices understand colour information as shades of red, green and blue.

Rule of thirds A compositional device that places the key elements of a picture at points along imagined lines that divide the frame into thirds.

Shutter The mechanism that controls the amount of light reaching the film or sensor by opening and closing when the shutter release is activated.

SLR (single lens reflex) A type of camera that allows the user to view the scene through the lens, using a reflex mirror. See also DSLR.

Spot metering A metering system that places importance on the intensity of light reflected by a very small portion of the scene.

Telephoto lens A lens with a large focal length and a narrow angle of view

TIFF (Tagged Image File Format) A universal file format supported by virtually all paint, image-editing and page-layout applications. TIFFs are uncompressed digital files.

Viewfinder An optical system used for composing and sometimes focusing the subject.

White balance A function that allows the correct colour balance to be recorded for any given lighting situation.

Wide-angle lens A lens with a short focal length.

FURTHER READING

Instructional books

Books about 4x5 landscape photography are few indeed. The best is *Large Format Nature Photography* by Jack Dykinga (Amphoto, 2001). Besides his artistry, Dykinga is a meticulous technician, guiding you through all the pitfalls of 4x5 and giving you the benefit of his long experience with the big camera. If you want to learn 4x5, there really is no other book.

John Fielder's *Photographing the Landscape* (Westcliffe, 1997) does concentrate a little on 4x5, but takes a broader view and is a great addition to your instructional library. Fielder's emphasis is on working in the wilderness, where he spent 25 years photographing Colorado.

Art Wolfe's best instructional book is *The Art of Photographing Nature* (Three Rivers, 1993). Trained as an artist, Wolfe illuminates the artistic side of landscape and nature photography as well as anyone.

Nature photography's best-known educator, John Shaw, turns his attention to the landscape in *John Shaw's Landscape Photography* (Amphoto, 1994), which is highly recommended.

Finally, one of the best all-encompassing guides to landscape photography in recent years is Tim Fitzharris's *National Audubon Society Guide to Landscape Photography* (Firefly, 2007).

Photography books

Books by Eliot Porter, the father of colour landscape photography, are always inspirational. Many can be found inexpensively at www.amazon.com.

Eliot Porter (New York Graphic Society, 1991) is a career retrospective and a good place to start. Another retrospective is *The Color of Wildness* (Aperture, 2005).

Other great Porter books include *In Wilderness is the Preservation of the World* (BBS, 1996); *The Place No One Knew* (Gibbs Smith, 1988); and *Intimate Landscapes* (EP Dutton, 1979).

Philip Hyde was the greatest American landscape photographer of the World War II generation. Some of his great books, all available on Amazon, include *Drylands* (Park Lane, 1987); *The Range of Light* (Gibbs Smith, 1992); *Navajo Wildlands* (Sierra Club, 1969); and *The Last Redwoods* (Sierra Club, 1963).

David Muench is the foremost colour American landscape photographer of the late twentieth century. Many of his books offer information about the camera and lenses used. A prolific photographer, the list of his books is long, and again many are available on Amazon. My favourites are *Primal Forces* (Graphic Arts Center Publishing Company, 2000); *Desert Images: An American Landscape* (Harcourt Brace, 1979); and *Nature's America* (Roberts Rinehart, 1995).

The late Galen Rowell might be categorized more as an adventure photographer than a landscape shooter, yet landscapes are strongly represented in his work. A recent retrospective called *Galen Rowell: A Retrospective* (Sierra Club, 2006) is a good place to start.

Art Wolfe's camera has been trained on a vast array of subjects, but two of his books have focused on worldwide landscapes in spectacular fashion. They are *Edge of the Earth, Corner of the Sky* (Wildlands Press, 2003) and *Light on the Land* (Atria Books/Beyond Words, 1991).

The World's Top Photographers: Landscape by Terry Hope (RotoVision, 2005) is a wonderful compendium of the work of the top landscape artists working today. Extended captions describe how the photos were made.

ABOUT THE AUTHOR

Tom Till has photographed landscape images in over 60 countries around the world, mainly with a 4x5 camera, but more recently with a Canon 21-megapixel digital camera. His work has appeared in thousands of publications worldwide, and he is the author of over 30 books. His photographic prints are collected around the globe, and his images have been displayed at shows in New York, Washington DC, Geneva, Paris, Qatar, Oman and many other locations. Till has received awards from *New Mexico* and *Arizona Highways* magazines, and a special award for conservation photography from the Nature Conservancy. In 2006, Till received the prestigious Fellow Award for Achievement in Nature Photography from the North American Nature Photography Association, one of only a few landscape photographers to do so. He has also been inducted into the Iowa Rock and Roll Hall of Fame.

Till still spends over 200 days a year in the field, but when not shooting he is a fan of rock and roll, movies, cosmology and astronomy, and the TV show *Lost*. He lives with his dog Gizmo in Spirit Canyon, Utah.

INDEX

To request a full catalogue of Photographers' Institute Press titles, please contact:

**GMC Publications, Castle Place, 166 High Street, Lewes, East Sussex BN7 1XN, United Kingdom
Tel: 01273 488005 Fax: 01273 402866**